NEW ORLEANS

PHOTOGRAPHY
AND
DESIGN
BERNARD M. HERMANN
TEXT
CHARLES "PIE" DUFOUR

LSU PRESS
LES·ÉDITIONS·DU·PACIFIQUE

New Orleans
First published in the United States in 1980.
© Copyright 1980 by Louisiana Press, New Orleans,
and by Société Nouvelle des Editions du Pacifique, Tahiti.
All rights reserved for all countries.
Published simultaneously in Canada.
Library of Congress catalog card number: 80-82900
ISBN: 0-8071-0799-9
First printing 1980-Second printing 1984.
Typeset, printed and bound in Japan by Obun Printing Company

CONTENTS

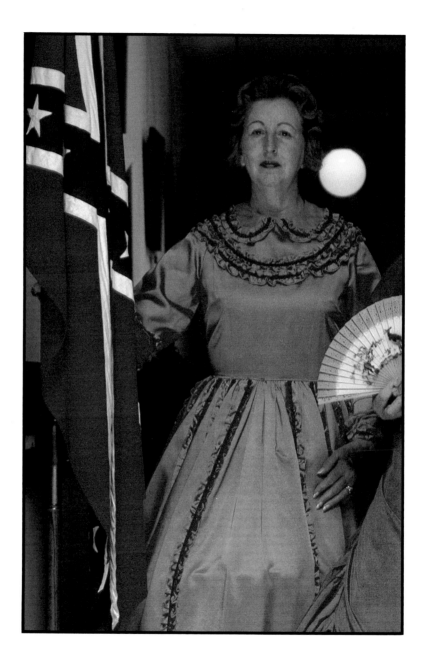

The Past is Prelude

New Orleans is a bit of everything — an exciting *mélange* of the old and the new, the past and the present, a unique American city.

Eight of the 10 flags that have flown in Louisiana have whipped in the breeze over New Orleans, which has had an always colorful, and sometimes turbulent, past of more than 26 decades. Successively, New Orleans has been French, Spanish, then French again, American, independent (with Louisiana, briefly, after Secession), confederate, and American once more. The city's unique character stems from the varied contributions of the peoples that have made up its population — Indians, French, Germans, Negroes, Spaniards, Acadians, Americans, Irish, Italians, Yugoslavs and other nationalities.

In its more than 260 years of existence, New Orleans has been buffeted by hurricanes and floods and violent epidemics of yellow fever and cholera, which swept into the city throughout the 19th century with devastating results. And yet New Orleans has survived, never losing its sense of humor, its *joie de vivre*, its verve, its spirit of tolerance. Sometimes, New Orleans is a victim of its virtues, and its traditional tolerance may slip easily into toleration of malfeasance and wrongdoing. More often than not, corruption is met with an indulgent smile, a carefree shrug, rather than with the indignation it deserves.

New Orleans is known throughout the world as the birthplace of jazz. But how many know that it was the first permanent home of grand opera in America? New Orleans is famous throughout the country for its French Quarter. But how many realize that the French Quarter was built by the Spaniards? How contrary can a city be? In the French Quarter, the original New Orleans, the sun rises on the west bank of the Mississippi. And past the French Quarter, the south-bound river flows due north. In New Orleans, the compass has almost been outlawed. Because of the wide embrace with which the river holds the sprawling city, New Orleans streets defy such designations as North, South, East or West, although they do exist. For instance, South Claiborne generally runs northwest, while North Claiborne generally extends southeast.

New Orleans is famous for its Creole cuisine, and it has many restaurants among the finest in the nation. But its culinary reputation does not depend solely on its gumbos and bisques and the classic Oysters Rockefeller. Prosaic (elsewhere) red beans and rice can be a dish to set before a king in New Orleans.

Among other delights of the palate is *jambalaya*, a legacy from the

Spanish regime in New Orleans. Jambalaya features rice and a little bit of everything else — "everything but the kitchen stove." Most every New Orleans home has its special recipe for jambalaya, but generally its ingredients are rice, shrimp, oysters, ham, chicken, sausage, and generous touches of various traditional herbs for seasoning.

New Orleans, itself, is a jambalaya, a fascinating mixture of "a bit of everything."

The Indians were here first, long before there was a New Orleans, indeed, long before a Frenchman laid claim to the vast area drained by the Mississippi River and its tributaries. As Indians went, they were no great shakes. French missionaries later commented that before they could make them Christians they had first to make them human beings.

But even these pot-bellied Choctaws, who wore their feathers around their tummies and not on their heads, recognized the importance of the future site of New Orleans where the Mississippi River and Lake Pontchartrain come closest together. On hunting expeditions, by using this six-mile portage, the Indians had easy access to both the river and the lake.

New Orleans' first "tourists" were Spanish Conquistadors, remnants of the expedition of Hernando de Soto, who floated down the Mississippi in 1543 on their way to Mexico. They sailed past the future site of New Orleans, but did not stop to settle it. Not for 175 years would New Orleans come into existence.

In 1682, the French explorer Robert Cavelier, Sieur de La Salle, set out from Canada to explore the Mississippi River. On April 9, he reached the Gulf of Mexico, and "in the name of the most high, mighty, invincible and victorious Prince, Louis the Great, by the Grace of God King of France and Navarre, Fourteenth of that name," he claimed for France all the land drained by the river, and called it *Louisiane* in honor of his king.

Louis XIV, after La Salle's return to France, authorized him to settle Louisiana. Full of enthusiasm and hope, La Salle set out again in 1684. It proved to be an ill-starred colonization project. A feud between La Salle and the naval commander of the expedition, Captain Beaujeu, resulted in a miscalculation as to where the mouth of the Mississippi was, and the ships sailed far past the river to Matagorda Bay in Texas. Once ashore, La Salle built a fort to protect his little band and then began a fruitless two-year search for the Mississippi. It ended on March 20, 1687, when he was brutally murdered by one of his own men.

France lost interest, seemingly, in Louisiana with the failure of La Salle's expedition and for more than a decade did nothing about it. It was

only when England began to look towards the Mississippi that Louis XIV ordered the Canadian Pierre Le Moyne, Sieur d'Iberville, to establish a French colony in Louisiana.

Iberville, accompanied by his young brother, Jean-Baptiste Le Moyne, Sieur de Bienville, reached the Gulf of Mexico early in 1699. Anchoring his big ships in the lee of an island, which today is still known as Ship Island, Iberville explored the coast of what is present day Mississippi. Then he set out in small boats sailing westward along the coast in search of La Salle's river, the Mississippi. He found it on March 3, 1699.

Because it was Mardi Gras, the culmination of the pre-lenten Carnival known to all Frenchmen, Iberville named the point of land where his party camped for the night Point du Mardi Gras, Mardi Gras Point. And the nearby little bayou, he named Bayou du Mardi Gras. These were the first place names of the vast Louisiana territory.

The French established a fort on Biloxi Bay and founded Mobile in 1702, but nearly two decades would elapse before the city of New Orleans would be established by Bienville, on orders from John Law's Company of the West. The Company of the West had taken over, in September 1717, the responsibility to exploit Louisiana, after Antoine Crozat, a wealthy Paris banker, gave up the unprofitable charter issued to him by Louis XIV in 1712.

Bienville established New Orleans in 1718, and from the city's beginning its survival was very much in doubt because of worthless settlers sent out from France, constant dangers from hostile Indians, jealousies and rivalries among leaders, and the ravages of nature in the form of floods, hurricanes and epidemics. Survive New Orleans did, but oddly enough the first stability to the French colony came only with the arrival of some German settlers. John Law, with his grandiose schemes, bankrupted France, but he finally succeeded in populating New Orleans and its environs with substantial colonists.

The coming of the Germans to French New Orleans launched it as an international city. In time the Germans were followed by African slaves, Spaniards, Acadians, Americans, Irish, more Germans, Italians, Yugoslavs and immigrants of many other nationalities. So international had New Orleans become in the ante-bellum period that in the 168,000 population listed in the 1860 census, nearly 41 percent were foreign born. An idea of the foreign influence on 19th century New Orleans can be gathered from the fact that in 1860 the city had 24,000 Irish-born and 20,000 German-born. It was the influx of foreigners, as well as waves of Americans, that enabled New Orleans to become in 1840 the third city in

the United States, after New York and Baltimore, to reach 100,000 population.

One of the most significant things the struggling Company of the West did for New Orleans, before it gave up the ghost and returned the administration of Louisiana to the French Crown, was to send out from France a small group of Ursuline nuns to tend the hospital and establish a school for girls. On August 6, 1727, six Ursulines reached New Orleans after a long and hazardous voyage. Today the Ursulines are the oldest continuous establishment, not only in New Orleans and Louisiana, but in the entire Mississippi Valley. One of the Ursulines was an 18-year-old novice named Sister Marie Madeleine of St. Stanislas, whose letters to her father in Rouen abound in youthful exuberance and, one suspects, youthful exaggeration.

"I can assure you that I do not seem to be on the Mississippi, there is as much of magnificence and politeness as in France," wrote Sister Marie Madeleine. "Cloth of gold and velours are commonplace here, albeit three times dearer than at Rouen." New Orleans, which has long been a gastronomic center of North America, got its first accolade for fine food from the little Ursuline novice. "We eat here meat, fish, peas, wild peppers and many fruits and vegetables such as bananas which are the most excellent of all the fruits," she wrote. "In a word, we live on buffalo, lamb, swans, wild geese and wild turkeys, rabbits, chickens, ducks, pheasant, doves, quail and other birds and game of different species..."

The flag of Bourbon France flew over the Place d'Armes until 1769, when the flag of Bourbon Spain was run up the flagpole. Louis XV had given Louisiana to his cousin, Charles III of Spain in 1762, but it wasn't until the spring of 1766 that the first Spanish governor, Don Antonio de Ulloa, arrived in New Orleans. He was driven out by a bloodless revolution in 1768, without ever having raised the Spanish standard over New Orleans. The following year, Alexander O'Reilly — Irish-born Spanish general — arrived with 2,600 troops and the rule of Spain was firmly established.

During the Spanish regime, Acadians, who had been expelled from Nova Scotia by the British, arrived in New Orleans. So did American traders from up-river and Spanish settlers, many from the Canary Islands. The city, small as it was, began to take on an international aspect. The great period of growth for New Orleans began with the Louisiana Purchase of 1803 and the coming of the steamboat, which revolutionized commerce on the Mississippi River.

Americans, first by the hundreds and then by the thousands, flocked

to New Orleans after the Louisiana Purchase. Foreigners, especially Irish fleeing their homeland because of the potato famine, and Germans seeking a new start in life along the banks of the Mississippi, came in large numbers in the 1820-1840 period.

There was no space available to the newcomers in the Vieux Carré, the Old Square which was the original city of New Orleans. Well-to-do Americans, those who either came with money or made it rapidly, invaded the suburban village of Lafayette, barely two miles up the river from French-Spanish New Orleans. Here they built sumptuous mansions on spacious plots, abounding with fine old oak trees and flowering shrubs, and they created what became known as the Garden District. The Irish and Germans, mostly poor, created ethnic neighborhoods of their own. The Irish settled near the river between the Vieux Carré and Lafayette, and their habitat became known as the "Irish Channel." The Germans, generally, settled downriver from the Vieux Carré.

The lush ante-bellum days of New Orleans, teeming with a fabulous river commerce, led to a time of trial when the Civil War broke out and New Orleans fell to the Union fleet of Captain David Glasgow Farragut in April, 1862. Defeat was followed by Occupation, and Occupation, when the war ended, was followed by Reconstruction. Harsh carpetbagger rule prevailed and corruption, never a scarce commodity in New Orleans under France and Spain, was rampant. Home rule was finally restored to Louisiana in 1877 and New Orleans began the long adventure of repairing the economic and psychological damage that a decade and a half of war, Occupation and Reconstruction had inflicted on its people.

But war and its aftermath were not the only cruel blows that buffeted New Orleans in the 19th century. Yellow Fever visited New Orleans many times between 1793 and 1905, dates of the city's first and last recorded epidemics. But no epidemic ever struck an American city with such fury as that of 1853 in New Orleans when five per cent of the total population was wiped out by the dread disease. There were 7,849 deaths out of 27,000 cases of Yellow Fever in a city of 150,000 population. These figures are even more staggering when it is noted that fully 30,000 people fled New Orleans during the epidemic. Other frightful visitations by Bronze John — one of the 152 recorded names for Yellow Fever — were in 1858 when 4,855 deaths were recorded; in 1867 when 3,107 lives were taken; and 1878 when there were 4,056 victims.

The amazing thing about Yellow Fever, not only in New Orleans but elsewhere in the country, is that no one suspected that the malady was transmitted by a mosquito. In New Orleans, epidemics broke out in

warm summers and in cool summers, in rainy summers and in dry summers, in poor or filthy neighborhoods and in rich or well-kept neighborhoods. Among these changing conditions, there was one constant that aroused no scientific curiosity. And that was the ever-present mosquito *Aedes aegypti* whose aliases were *Stegomyia calopus* and *Stegomyia fasciata*. It was not until 1881 that the Cuban physician, Dr. Carlos J. Finlay, finally announced to an unbelieving world his theory that the carrier of Yellow Fever was the *Aedes aegypti*. After the Spanish-American War, Walter Reed and his associates in Havana demonstrated without a doubt that it was the culprit.

New Orleans has long been attractive to writers, both native sons and daughters as well as adopted ones, and such authors as Walt Whitman, George W. Cable, Grace King, O. Henry, Lafcadio Hearn, Lillian Hellman, J. Hamilton Basso, Lyle Saxon, Harnett T. Kane, Hermann B. Deutsch, E.P. O'Donnell, Fanny Heaslip Lea, Gwen Bristow, Tennessee Williams, Robert Tallant, Roark Bradford, Marquis James, Sherwood Anderson, Hodding Carter, William Faulkner, Oliver La Farge, Carl Carmer, Frances Parkinson Keyes, Shirley Ann Grau, and Thomas Sancton, all lived and wrote in New Orleans.

In the 1920s, New Orleans' French Quarter was a haven for literary folk, both professional and amateur. Professor James Feibleman of Tulane University, philosopher, author, poet, has captured the flavor of "the old days" in which he shared: "The French Quarter furnished the kind of sensually pleasant and socially tolerant atmosphere which artists have sought and found in the Paris of Montparnasse and New York of Greenwich Village. The climate was mild, the heat comforting, and the pervasive smells were good; in particular the odor of roasting coffee drifting over the wholesale district across Canal Street early in the morning. There were few night clubs in the Quarter in those days, but mostly it was given over to an assortment of people moving quietly, rich people and poor, happy to be left alone just to be by themselves."

Historians who have chronicled the story of New Orleans include François Xavier Martin, Charles Gayarré, Alcée Fortier, John Smith Kendall, Charles E. O'Neill, S.J., John C. Chase, Samuel Wilson Jr., Leonard V. Huber and Ray Samuel.

Musically, New Orleans established the first permanent home of opera in America and it was the birthplace of jazz. Its star performers include Shirley Verret and Norman Triegle in opera, and Louis Armstrong, Pete Fountain and Al Hirt in Jazz.

John James Audubon made, in and about New Orleans, many of

the studies of birds for his famous *Birds of America*. Other distinguished early painters included Louis Antoine Collas, Richard Clague, Samuel Walker, Paul Poincy, and Adrien Persac. More recent New Orleans painters identified with New Orleans were Edgar Degas, William and Ellsworth Woodward, George F. Castledon, Alexander Drysdale, Boyd Cruise, John McCrady, Charles Bein, Knute Heldner, Dr. Marion Ida Kohlmeyer, Mildred Wohl Souchon, Nell Pomeroy O'Brien, Morris Henry Hobbs, Andrew Lockett, and Keith Temple.

Sculptors Enrique Alfarez, Angela Gregory, Rai Grainer Murray and Lin Emery have gained reputations in the art world.

New Orleans, no stranger to grandeur and tragedy in its more than two and a half centuries of existence, looks back with pride on its historic and cultural past and looks forward with confidence to its future. This future is deeply committed to the petro-chemical industry which has boomed in Louisiana since the end of World War II. Along the Mississippi's banks, both above and below New Orleans, many industrial plants have been erected to tap Louisiana's great reserves of oil, natural gas and sulphur. Almost 20 per cent of the nation's oil comes from Louisiana and the state's natural gas reserves represent more than 28 per cent of the nation's total. The Port of New Orleans, always an important factor in the economy of Louisiana is, in the last two decades of the 20th century, heavily engaged in moving industry's raw materials and finished products.

That New Orleans has a great future is the direct consequence of the city's conquest of Nature during its long past. It can be easily demonstrated that few worse spots to establish a city exist in Louisiana. New Orleans is built in a swamp, a veritable bowl, and all but a few areas of the city are below sea level, in some places as much as five feet. Couple this with the fact that New Orleans shares with Mobile the dubious honor of being the wettest city in the United States, each with an average annual rainfall of approximately 60 inches, and the disadvantages of the site are readily apparent. Special pumps, invented locally, literally "lift" the rainfall out of New Orleans' "bowl" and deliver it through drainage canals into Lake Pontchartrain.

On the subject of canals in New Orleans, the artist-author-historian John C. Chase in his *Frenchmen, Desire, Good Children, and Other Streets of New Orleans* declares: "New Orleans has always been, and still is, a city of canals, making it properly symbolic that the city's main street should be so named. Against Venice's 28 miles of canals, New Orleans…counted 108 miles!"

More than two and a half centuries of cultural jambalaya have given the old Creole city of New Orleans its unique flavor. This potpourri of architecture and atmosphere, customs and cuisine, music and merriment and the festive spirit embodied in Mardi Gras, have set the city apart from its American sisters. New Orleans is more than bricks and mortar; it is a state of mind.

15

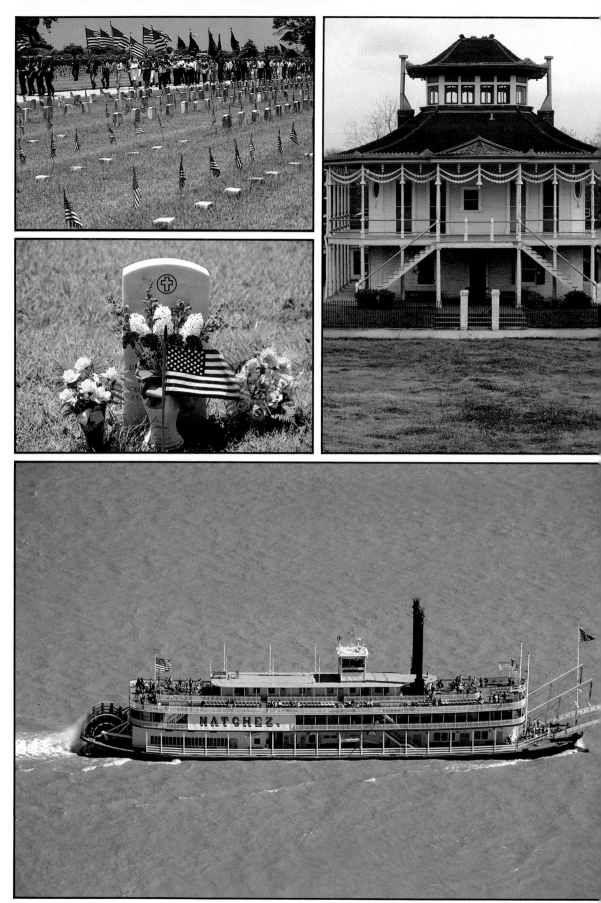

The Mississippi River has been the lifeline of New Orleans. It was the river that
brought the French here. It was the river that lured the British to disaster in 1815
at Chalmette, where American flags now adorn the graves on Memorial Day. It
was the river with its steamboat traffic which led to the lush Greek Revival

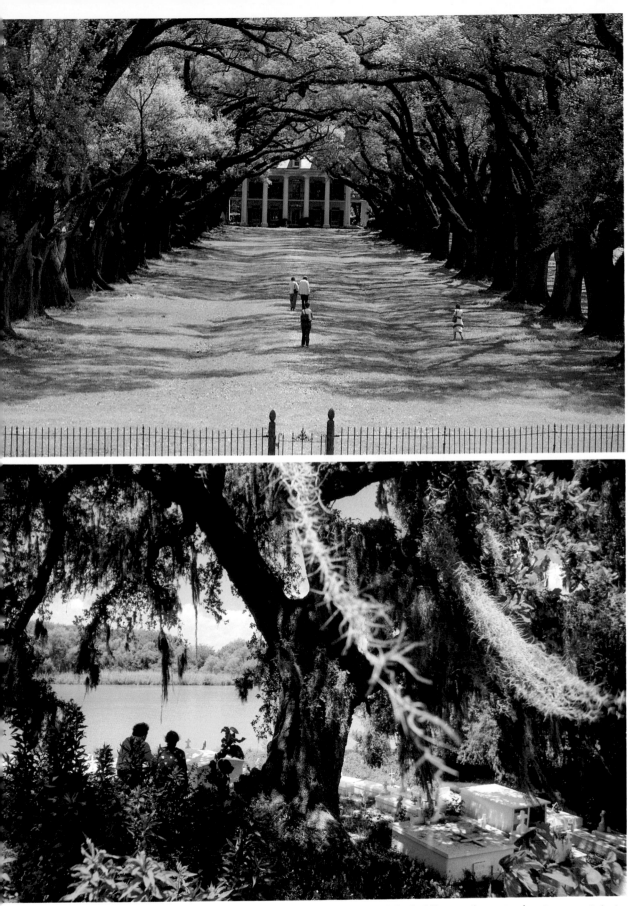

plantation homes, such as tree-framed Oak Alley and inspired a river captain to model his house on his beloved steamboat. It was the river and the nearby bayous which made contributions to folklore and legend, such as the myth that beneath the Spanish Moss of ancient trees lies Napoleon Bonaparte.

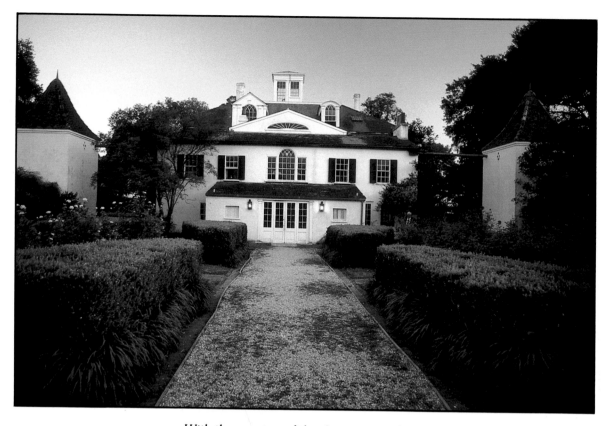

With the coming of the Americans after the Louisiana Purchase, large plantations were established along the Mississippi near New Orleans, each with its stately mansion, usually built in the Greek Revival style so popular in the U.S. in the 1830s and 1840s. One of the most imposing of these ante-bellum mansions is Houmas House, named for the Indian tribe that once owned the land on which it is situated. Houmas House was restored by Dr. George Crozat, who bears the same name as the Parisian banker, Antoine Crozat, who was the first to hold the trading monopoly in the vast Louisiana Territory.

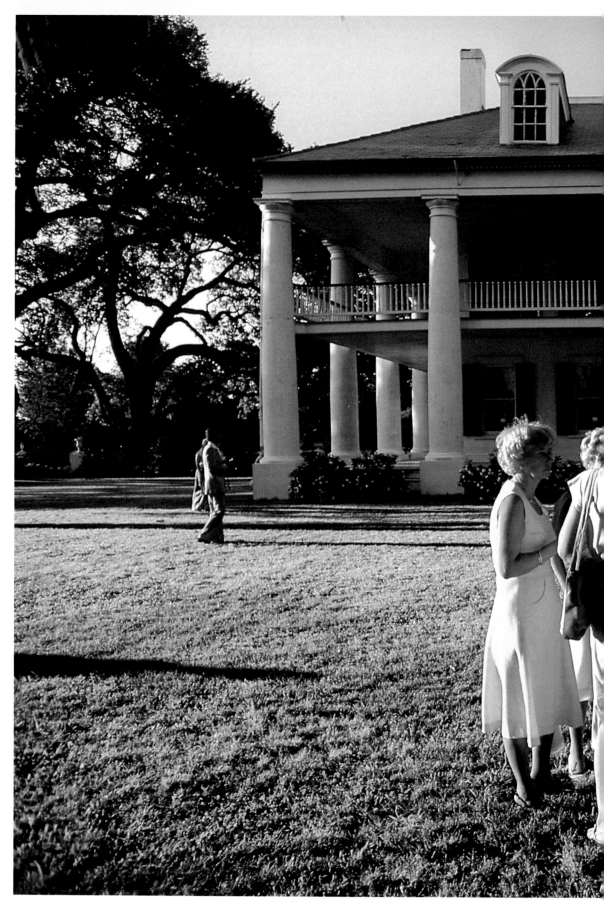

Houmas House is often host to garden parties. Its columns,
its galleries, extending around three sides of the mansion, present it today as it
appeared in the 1840s when it was one of the glories of the River Road.

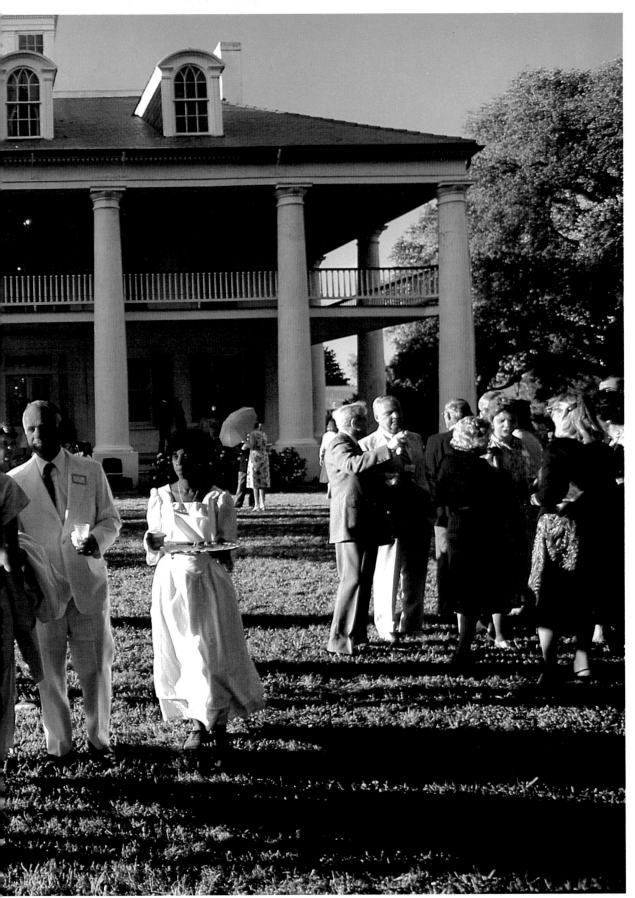

*From the dormer windows and the lookout atop the roof,
one may view the river, which is obscured at ground level by the levee
that protects against flooding when the river rises.*

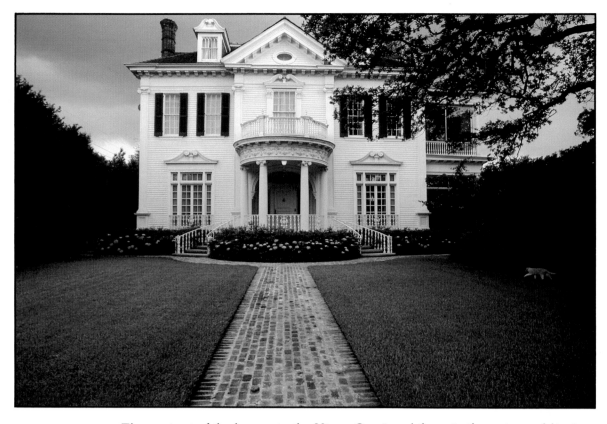

The contrast of the homes in the Vieux Carré and those in the uptown American city is marked. Modern homes often reflect the influence of the Greek Revival, but they could exists in dozens of other American cities. In the Garden District, however, the iron-balconied houses, set among trees, shrubs and flowers, have a character all their own, but most of them reflect, in one way or another, the architectural tradition with which ante-bellum New Orleans was much enamored. Some of the Garden District homes are still occupied by families whose forebears built them in the years of great prosperity before the Civil War, when the Garden District was the town of Lafayette, less than two miles above the French Quarter.

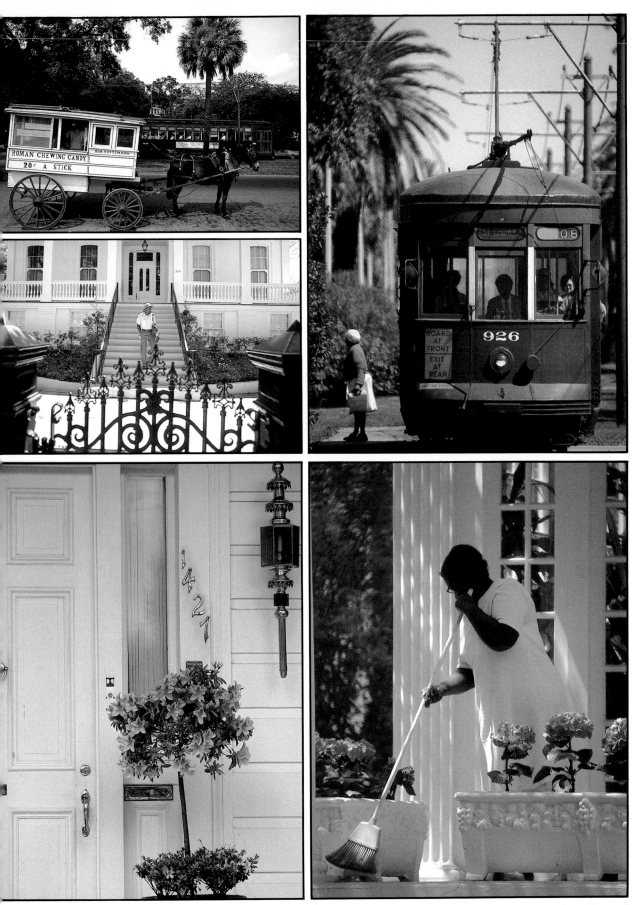

*Still preserved today in the Garden District and residential
St. Charles Avenue is a tradition of gracious living. Old homes, old gardens,
old retainers are all part of the scene, as, too, are the old street cars
and the ancient horse-drawn cart of the long-familiar candy man.*

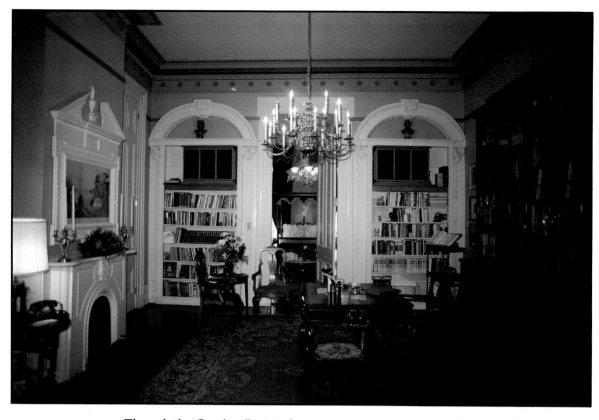

Though the Garden District homes appear attractive to the passer-by, their true charm rests in their interiors, where tasteful decors still reflect a 19th century American life style. This, too, is reflected in homes of old Creole families, who left the Vieux Carré and Esplanade Avenue to establish themselves in uptown New Orleans. The Leon Sarpy family, three generations of which are shown under the portrait of a Sarpy ancestor, is one example of Creole movement into American New Orleans. Mr. Sarpy, who once reigned as Rex, King of Carnival, delivered in French a welcome address to President Charles de Gaulle on his memorable visit to New Orleans.

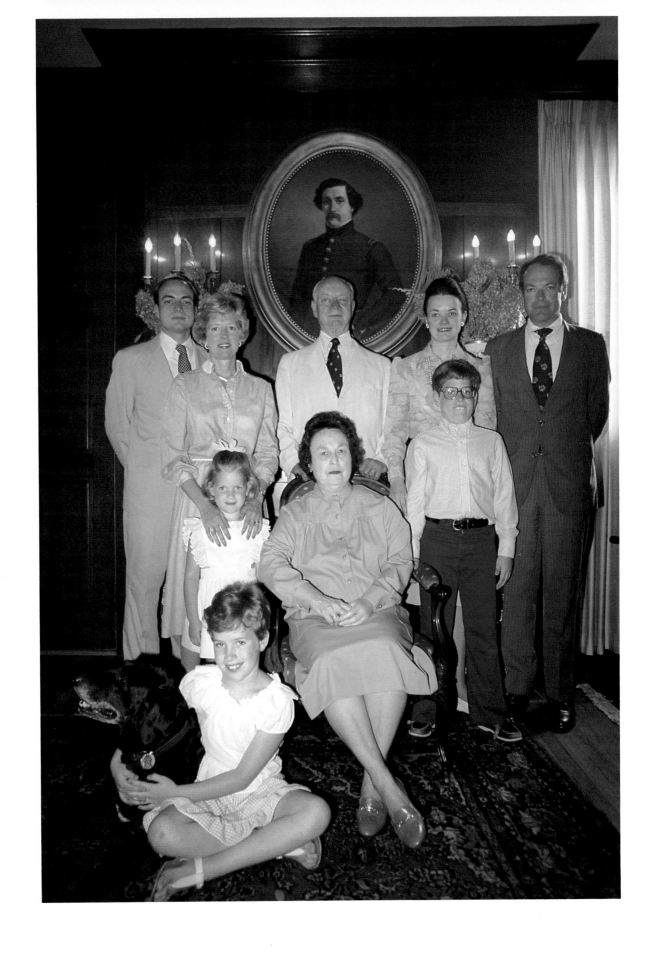

From the earliest days, both primary and higher education were largely the responsibility of private or religious institutions. Side by side, facing Audubon Park in uptown New Orleans, two great universities exemplify this fact today. Tulane University, the origins of which go back to 1834, is privately endowed, while Loyola University, founded early in the 20th Century, is conducted by the Jesuit order. Graduates of both universities play significant roles in the daily affairs of the city.

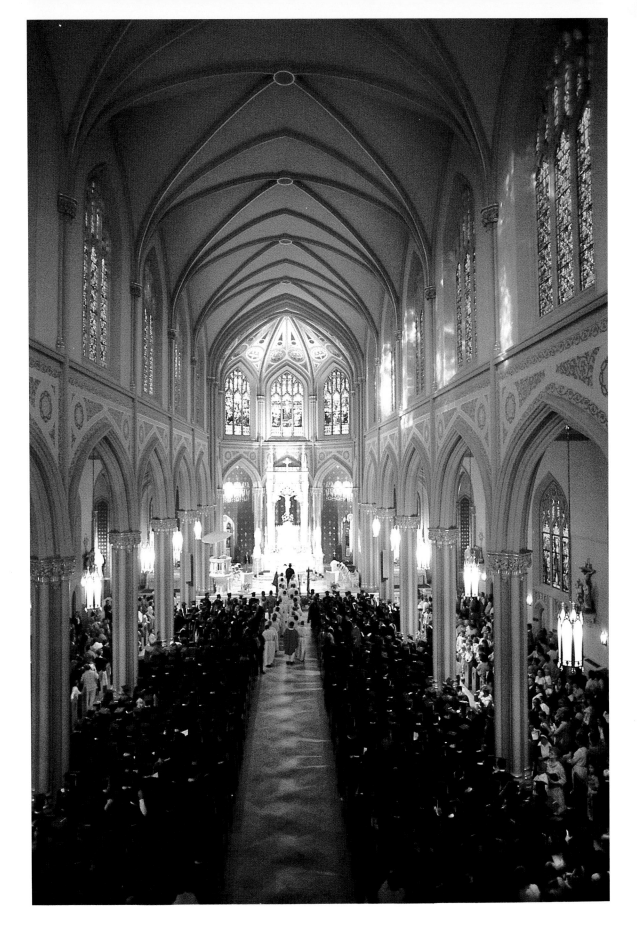

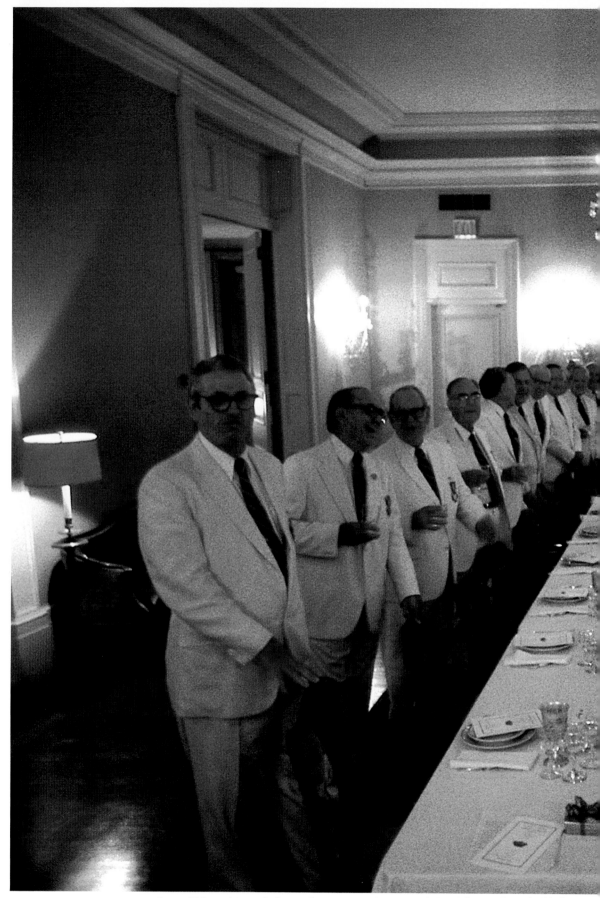

Social life in New Orleans has created many clubs. The Pickwick Club was originally identical with the Mistick Krewe of Comus, the oldest of Carnival organizations. The even-older Boston Club has no formal identification with any

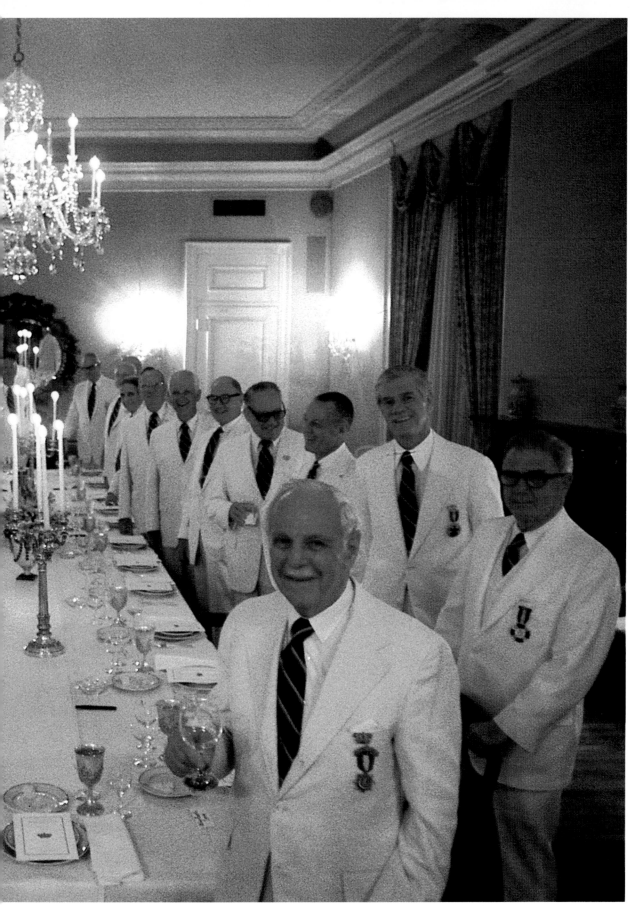

Carnival krewe, but Rex, King of Carnival, is traditionally chosen from its membership. Ex-rulers of Carnival, members of an ultra-exclusive club of those who served as Rex, annually hold a banquet, such as this one at the Boston Club.

New Orleans has flourishing chapters of many national patriotic societies. Ladies from such groups as the Daughters of the American Revolution, the United Daughters of the Confederacy, the Colonial Dames, to name only a few, often participate in the annual Spring Fiesta, some activities of which take place in Jackson Square. Visitors to the Spring Fiesta seldom miss St. Louis Cathedral, which is a "museum" as well as a place of worship. The seat of the city's Catholicity, the cathedral is dedicated to the canonised king of France, Louis IX. Above the main altar a painting depicts St. Louis announcing the Seventh Crusade, as its incription in French states.

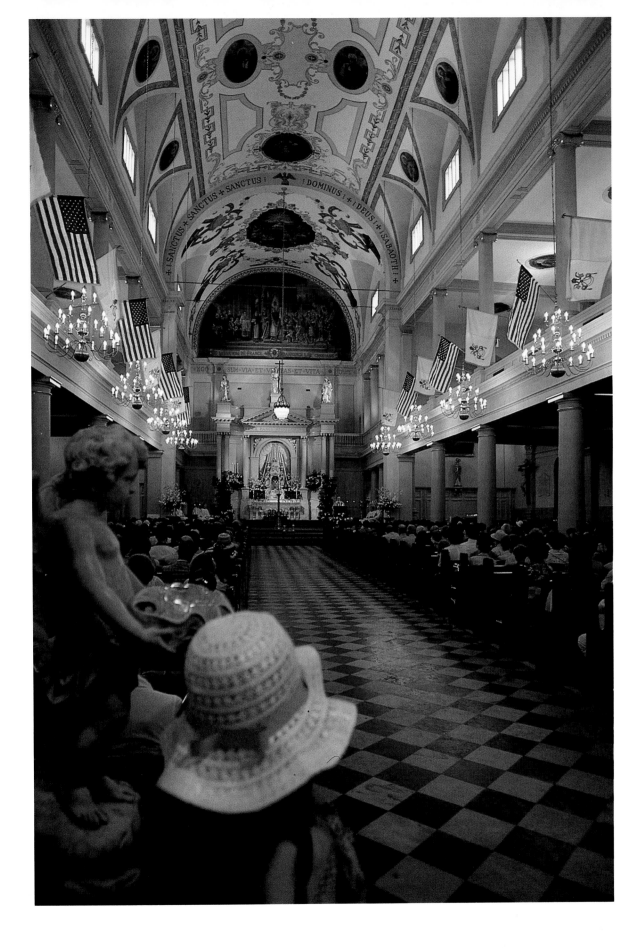

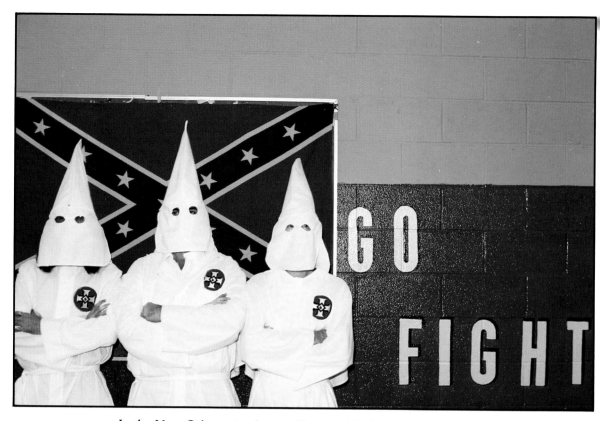

In the New Orleans tradition of live and let live, of contrast and contradiction, it is not surprising that such groups with diverse aims as the Ku Klux Klan, on one hand, and the Knights of Columbus and the Knights of Peter Claver, on the other, can exist in the city and its environs. Here, in ceremonial attire, the two organizations of Catholic knights march together harmoniously after a religious function in the Cathedral.

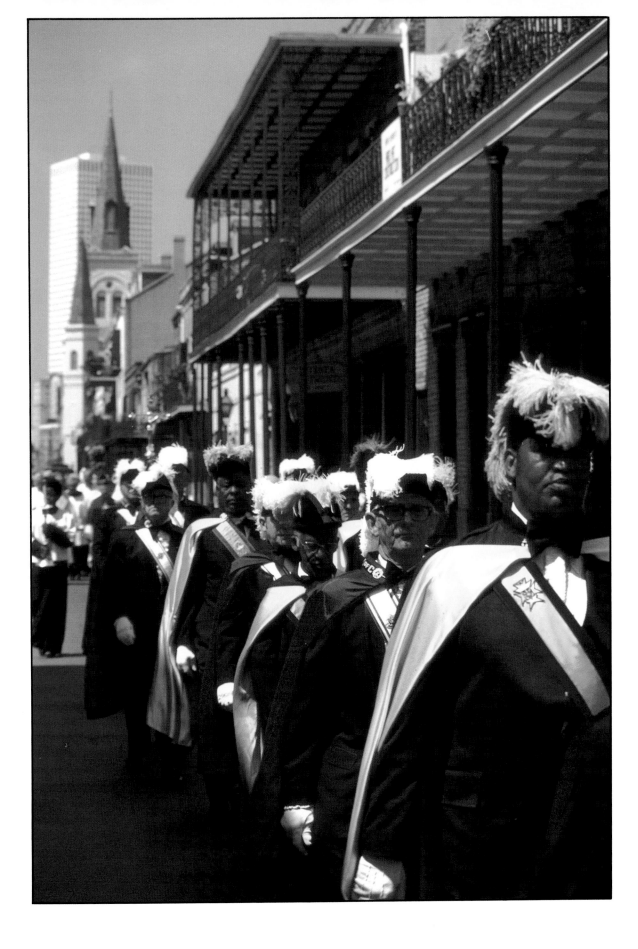

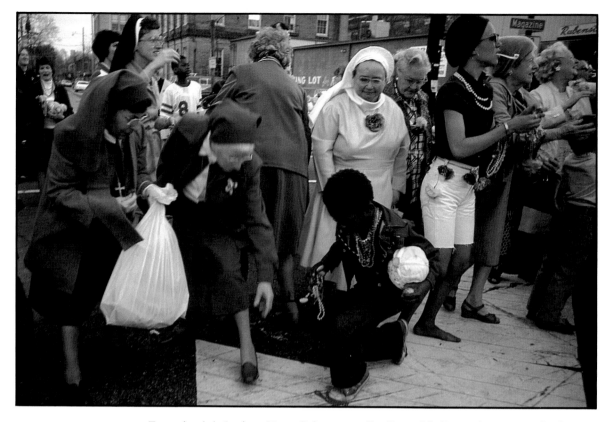

Everybody's Irish in New Orleans on St. Patrick's Day when even the beer is green-tinted. The "Irish Channel," a section of New Orleans that was largely inhabited by Irish immigrants in the mid-19th Century, is the home of the celebration, which now draws wide participation in a parade. Always ready for St. Patrick's Day action is former Grand Marshal "Red Jack" Burns, who still arrives for the parade in full regalia, including a ribbon across his chest with the invitation: "Kiss me, I'm Irish."

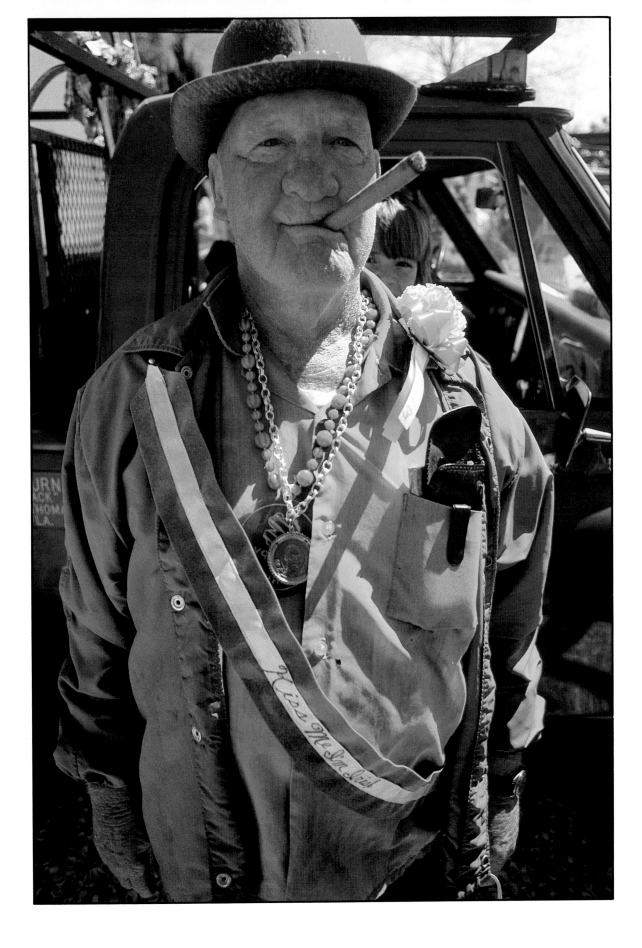

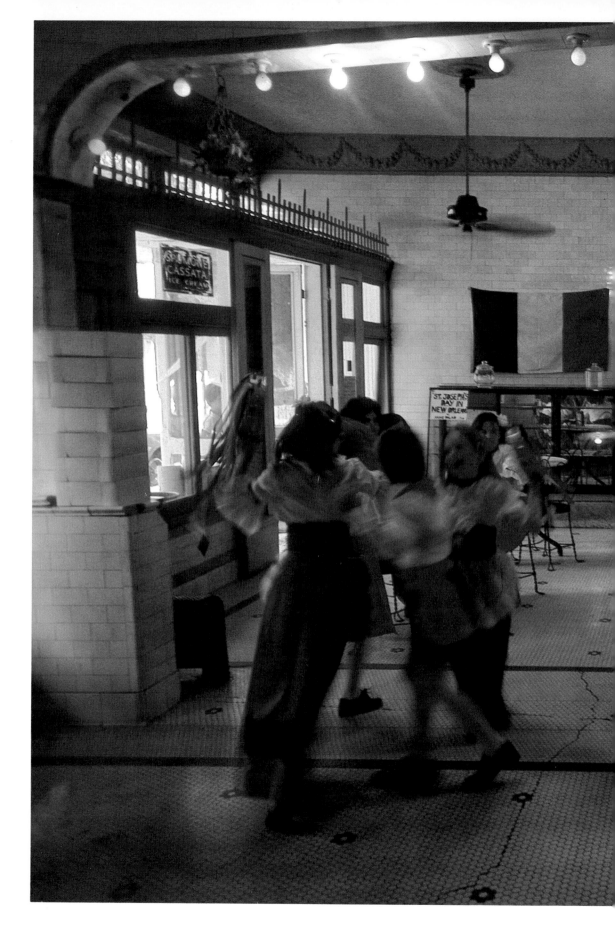

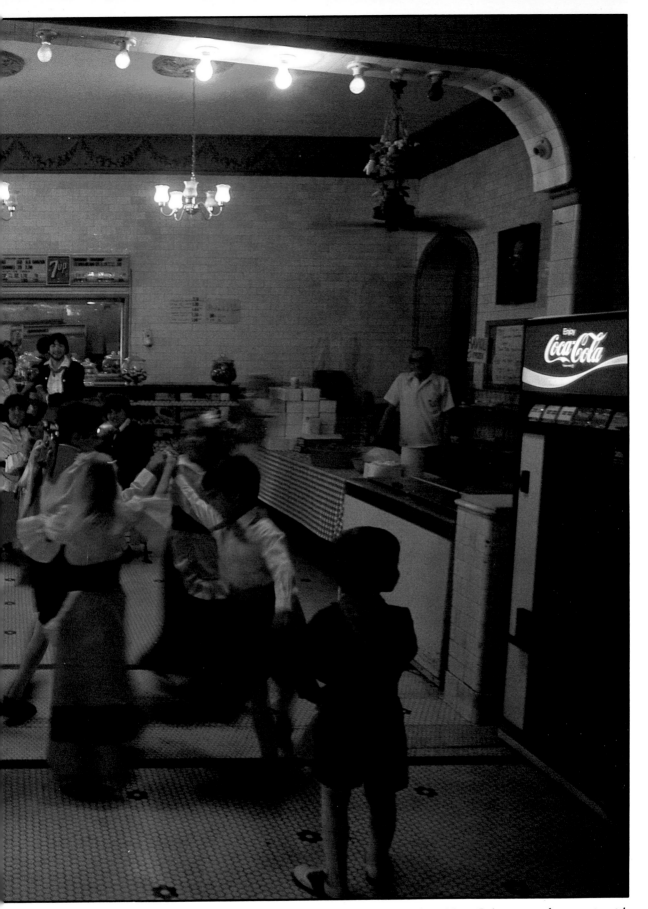

Italian Folk Festivals in New Orleans are frequent, with special attention to St. Joseph's Day, when eleborate food displays adorn family altars. A parade and folk dancing also feature in the festivities. Here in Brocato's Ice Cream Parlor, where authentic Italian "gelati" may be had, a Sicilian folk dancing group rehearses its routine.

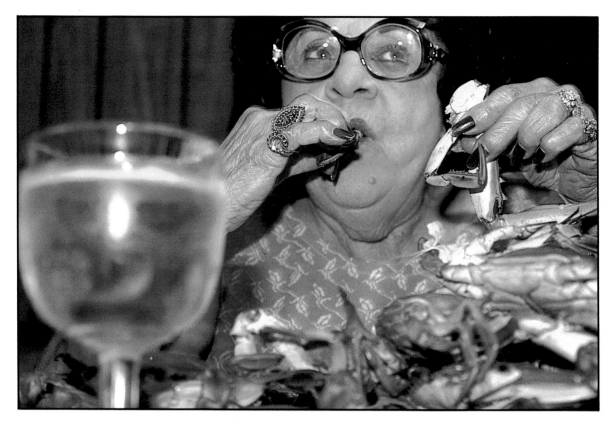

Man may not live by bread alone, but in New Orleans and the nearby bayou country, one may live by sea food alone, such is the diversity of the "fruits de mer" which fishermen bring to the markets. Shrimps, crabs, oysters, crawfish and fish of many varieties are specialities of the area. Modern refrigeration makes it possible today for around-the-calendar availability of products of the sea.

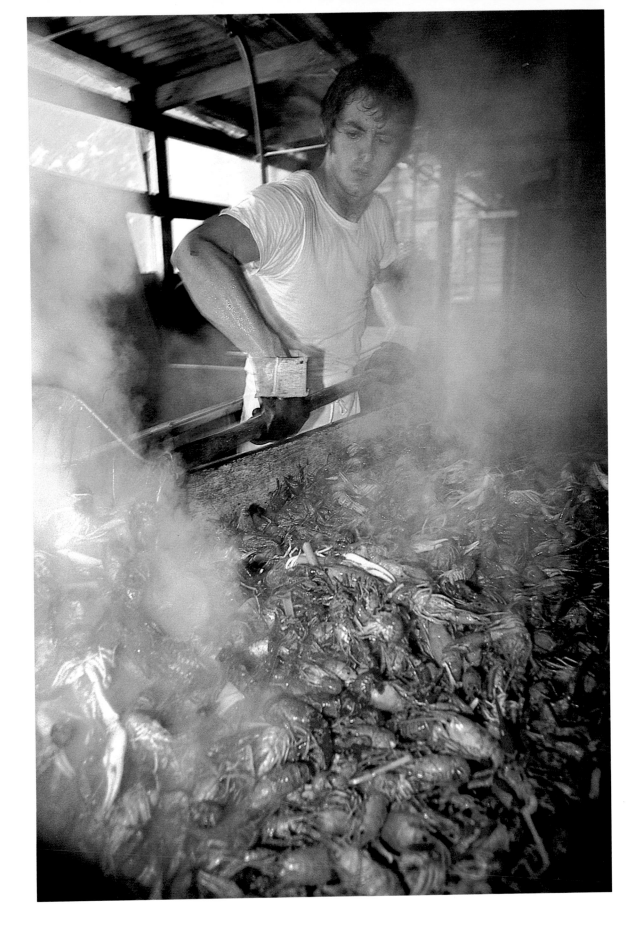

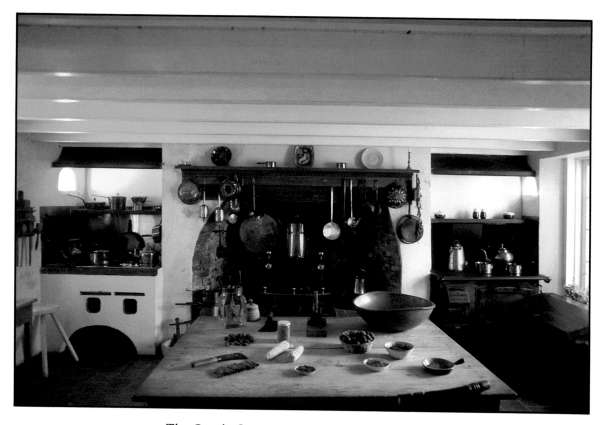

The Creole Cuisine is a melange of French, Spanish and Afro-Caribbean contributions. The delectable dishes born of this partnership had their origin in open ante-bellum fireplace ovens. The evolution to today's modern cooking equipment has in no way changed the unique character of the Creole Cuisine. New Orleans not only cherishes its cuisine, but records it for posterity and enthusiastically shares it with others through an amazing number of cook books.

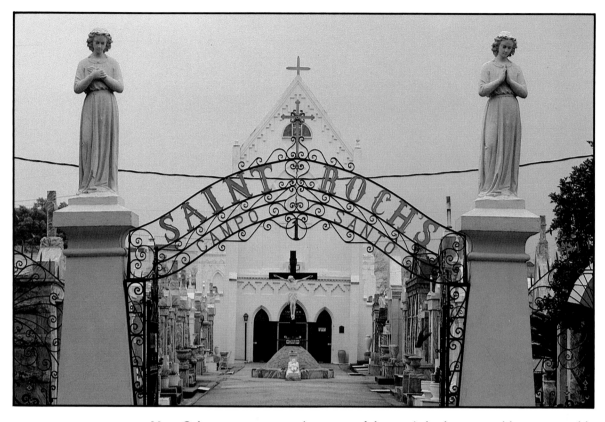

New Orleans cemeteries, because of the city's high water table are veritable "cities of the dead," the "houses" of which are above-ground tombs of various architectural styles. The cemeteries present two essential facts about the city: its geographical growth and the ethnic components of its population. From the city's beginning, cemeteries were located on its extreme outskirts. With each expansion, new cemeteries were established on the new outskirts. Today, the city has enveloped them all. The names inscribed on the tombs—French, Spanish, German, Irish, English, Italian and other nationalities—show that New Orleans' claim to be "The International City" is attested by its dead.

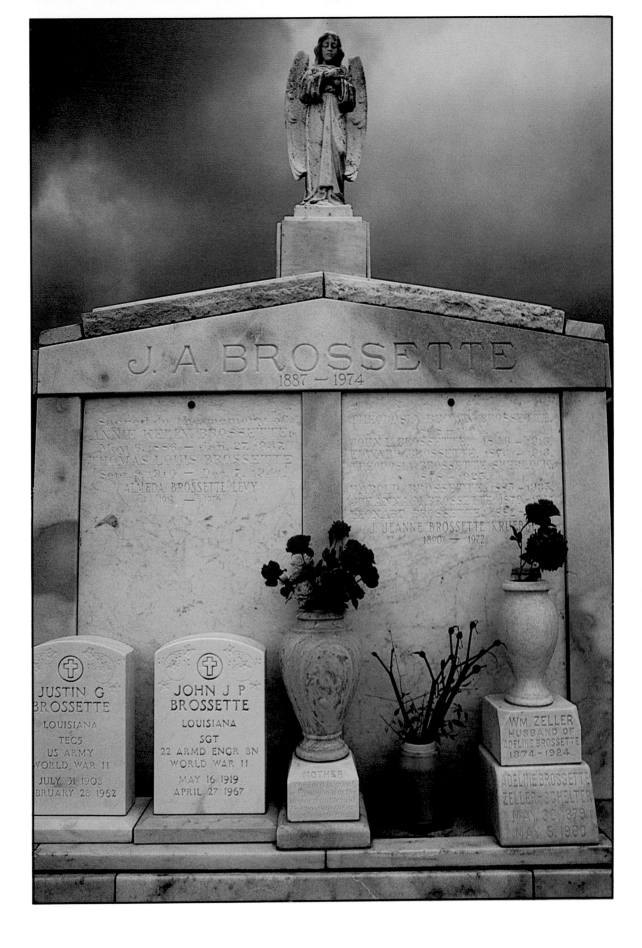

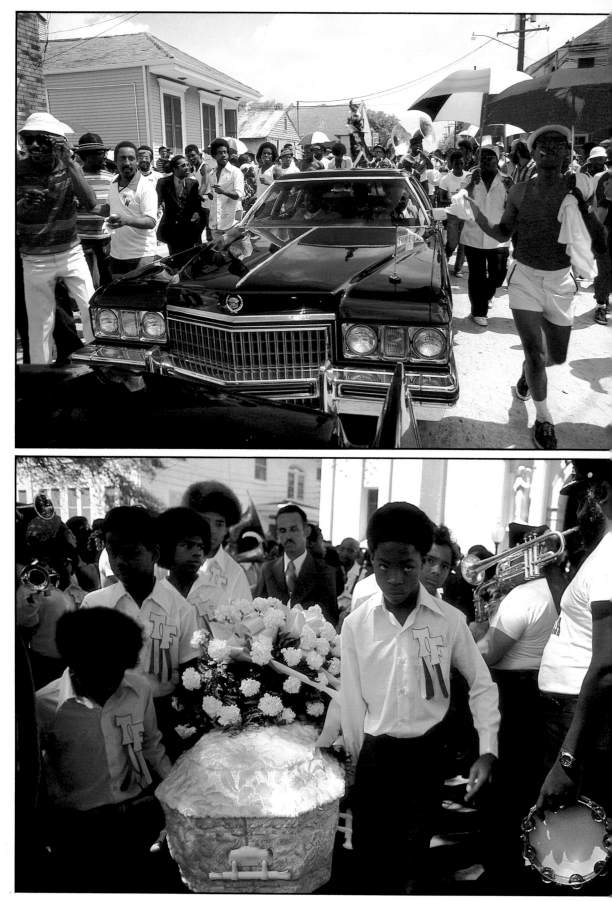

Traditionally given to fellow musicians, the Jazz funeral (upper left) can also be held by a club, church, family and friends for any member of the community as a special dedication. Here, in lower downtown New Orleans, the casket of a young boy is carried to the hearse by his "Bucketmen" and "Tamburines and

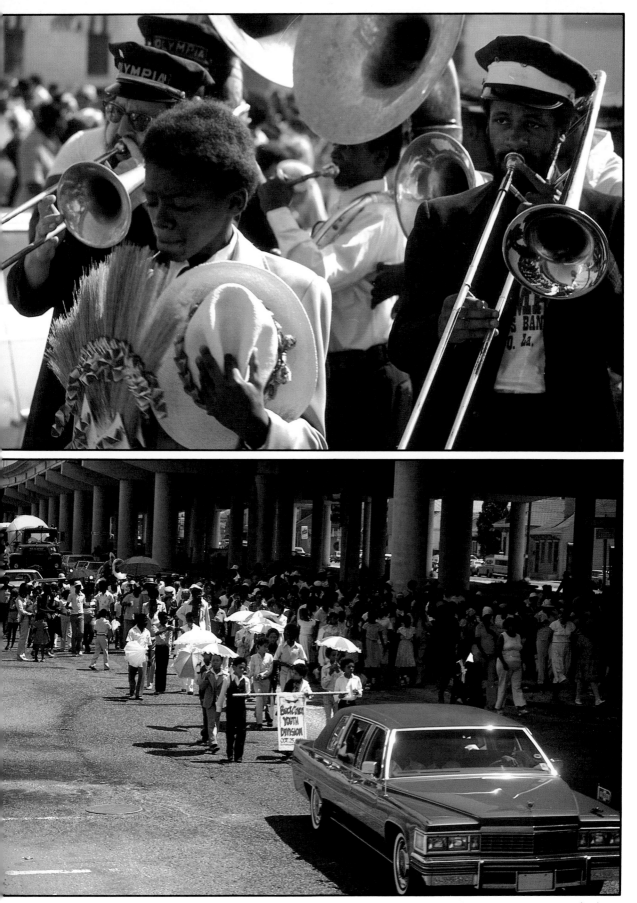

Fans" friends. The Grand Marshal expresses his formal mourning with slow, swaying body movements, while the black-capped brass band plays the "Dirge," according to the century-old tradition. Then, slowly marching to the beat of the band, the community expresses its sorrow as the funeral procession moves on.

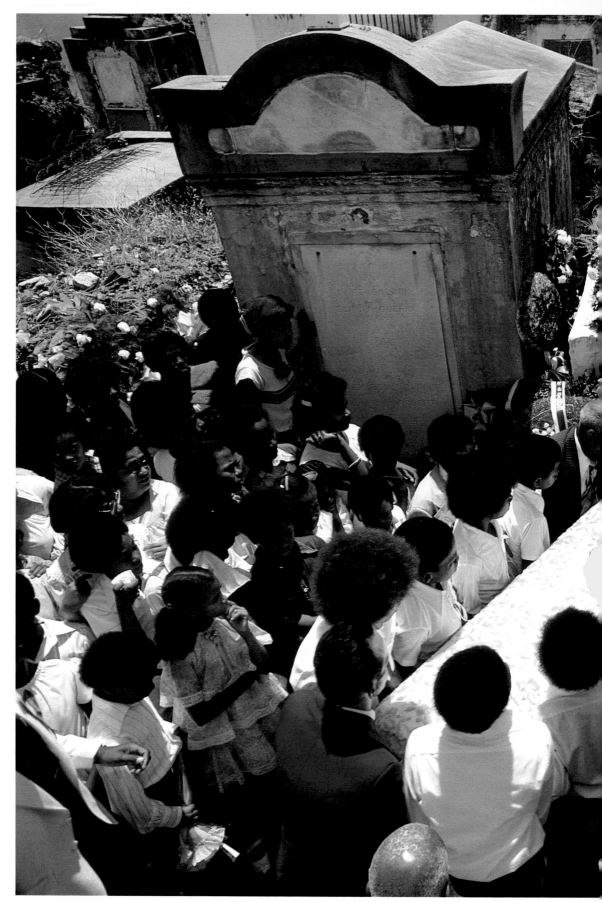

In the old St. Louis No. 2 Cemetery, the Olympia Brass Band has "turned the body loose" with a long drum roll, according to custom. In the sudden silence, the emotion heightens and reaches a climax when the coffin is consigned to the grave. Meanwhile, outside the graveyard, the band drummer tightens his snares

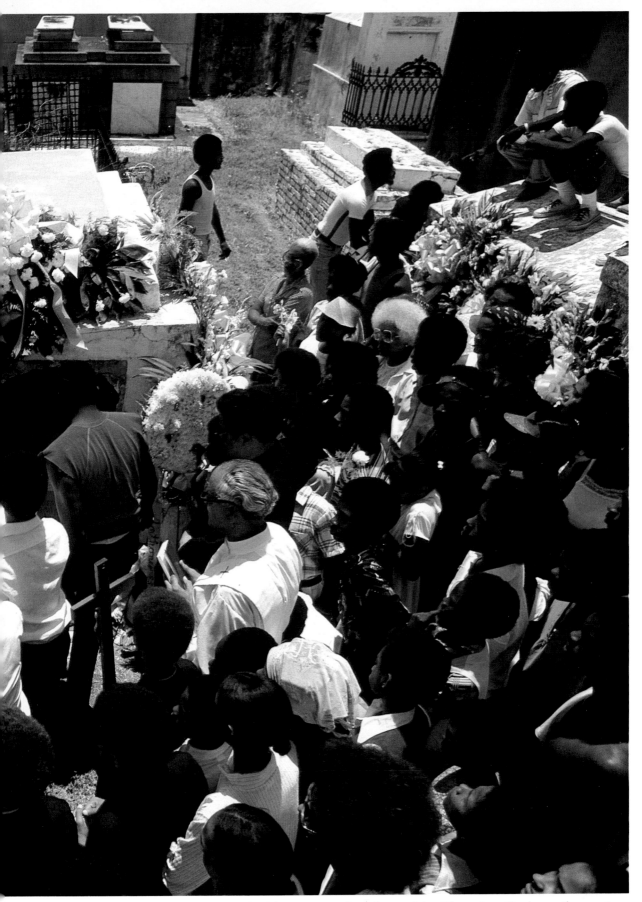

and soon the blasting marching beat of the Olympia will release the pent-up tensions. The lively second line—in jazz jargon, the "second line" means the throng accompanying a marching band—jauntily moving down Claiborne Avenue, is a symbolical re-affirmation of life's victory over death.

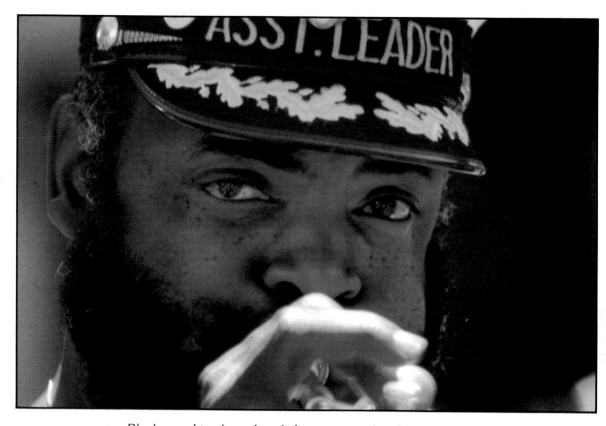

Black marching brass bands first appeared in the streets of New Orleans around
1880. By the turn of the century, having mastered sophisticated European
written music, some of the brass band musicians, inspired by "Ragtime," began
to improvise freely on the Afro-Caribbean drum beat, so familiar to Congo
Square. Using their standard repertoire and instrumentation, they created for
their own pleasure syncopated, "ratty" music, which caused listeners to jump to
their feet and dance furiously. Thus was instrumental jazz born. Today, the
Olympia Brass Band participates in many New Orleans events, and, at the Jazz
Festival annually, the venerable Onward Brass Band still parades as proudly
as when young Louis Armstrong played cornet in its ranks.

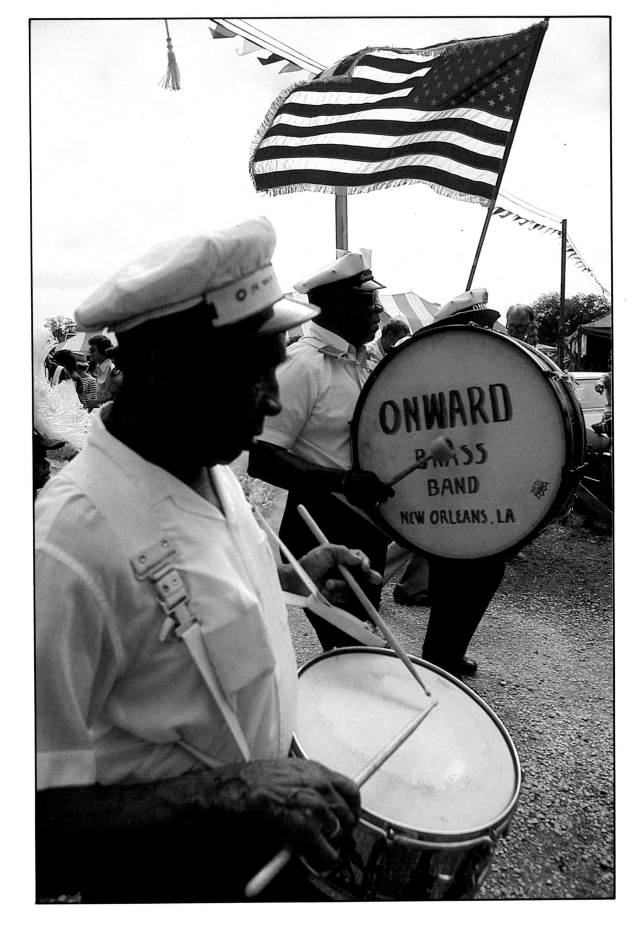

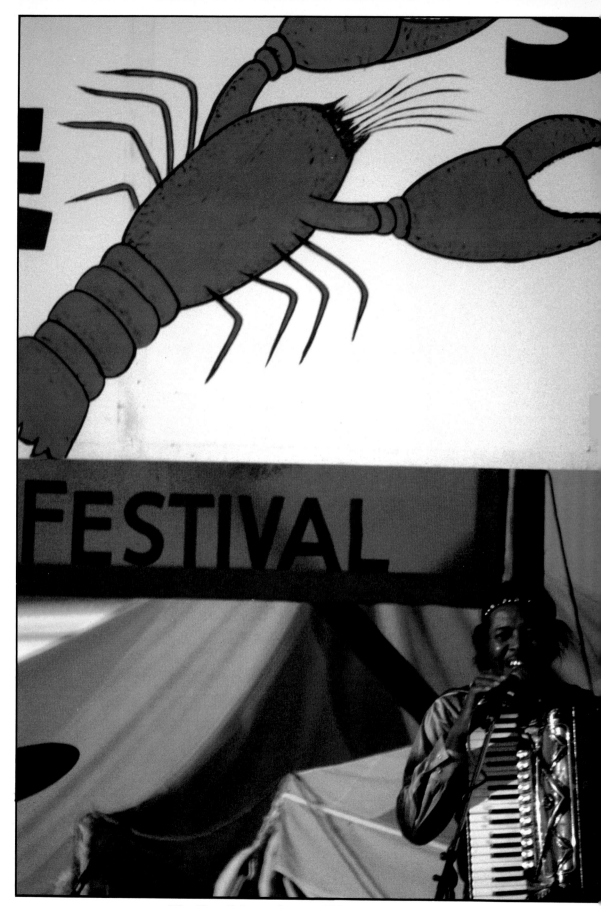

The New Orleans Jazz and Heritage Festival, held each spring at the Fair Ground Racetrack, is a massive salute to the city where jazz was born. All possible types of jazz-related music, sifting from the various tents and open air platforms, mingle through a common bond. Clifton Chenier, King of Zydeco, a

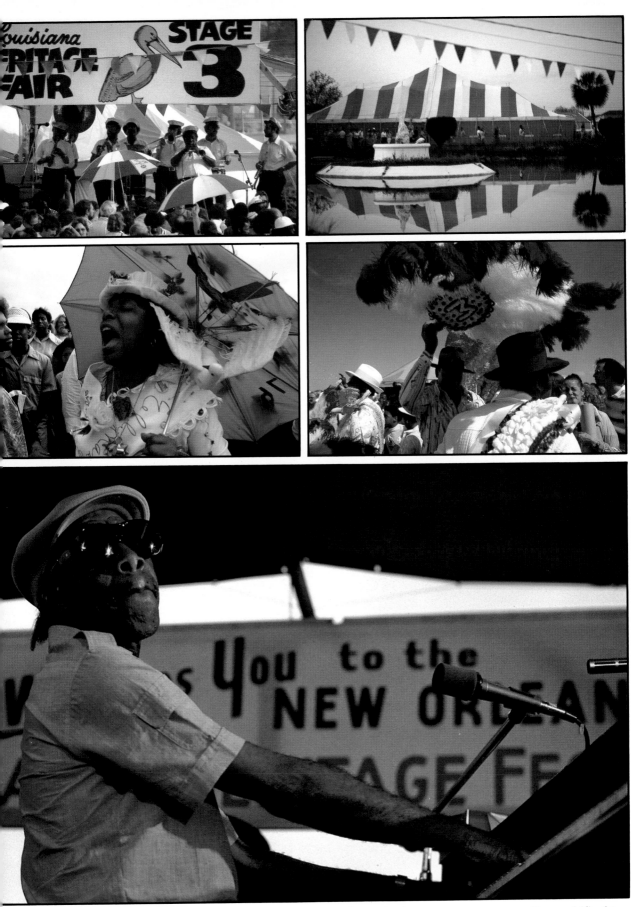

black variant of Cajun music from the bayous, announces with a goldflashing
smile: "Laissez les bons temps rouler." While marching clubs wander among the
tents and stages, the late Professor Longhair's piano beat holds
the crowd under its spell.

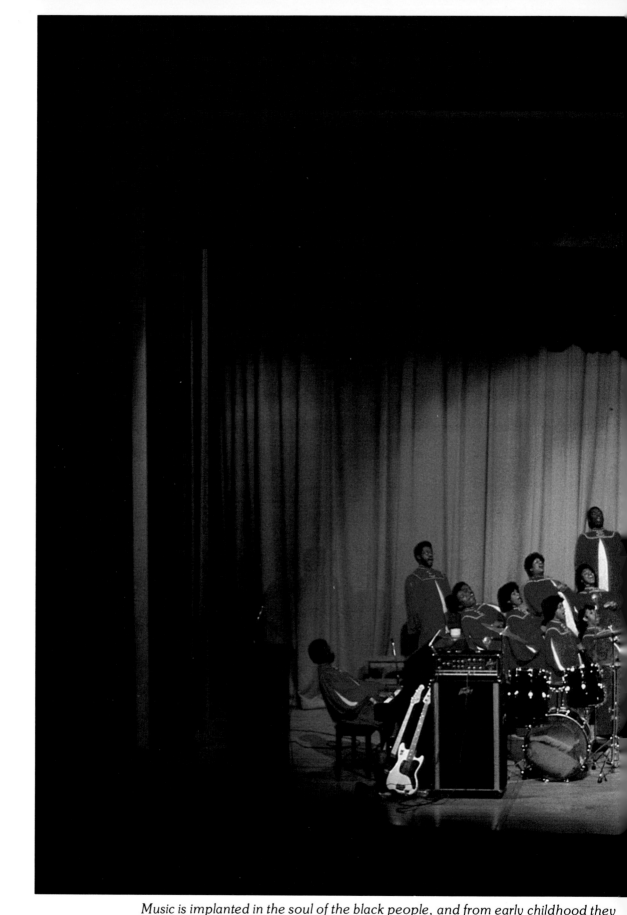

Music is implanted in the soul of the black people, and from early childhood they express themselves spontaneously in song. "Work Songs," which harmonized physical activity with vocal rhythm have long been sung by black Americans, laboring in the fields or in work gangs. "Sorrow Songs," ancestors of the

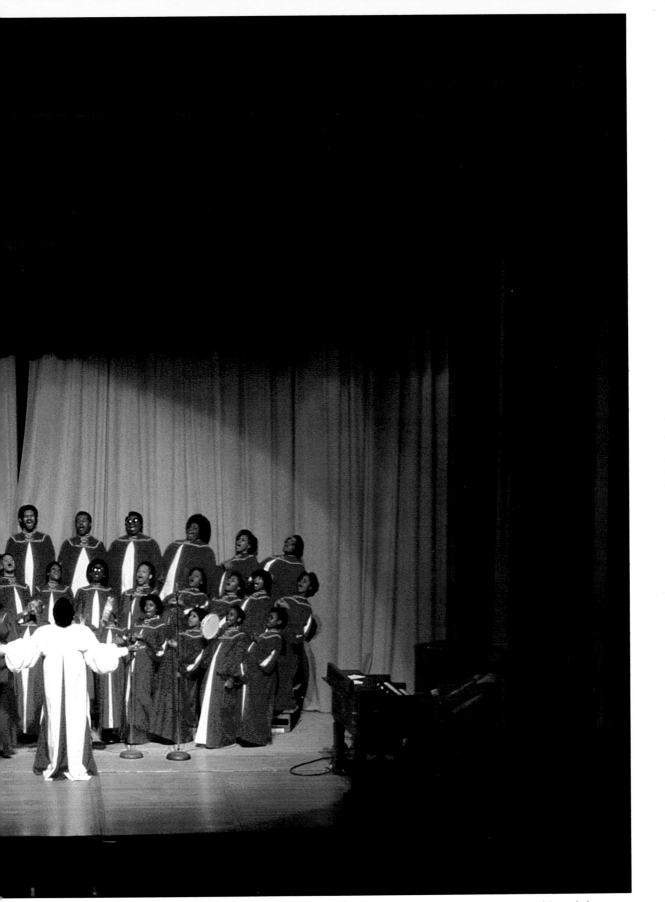

"Blues," helped them to bear life's misery. Hope in a better world and devotion to God are expressed in the "Gospel Songs," which today are still sung in old wooden churches of the city, in the always-crowded Gospel tent at the Jazz Festival, or, as shown here, in a recital in Tulane University's Dixon Hall.

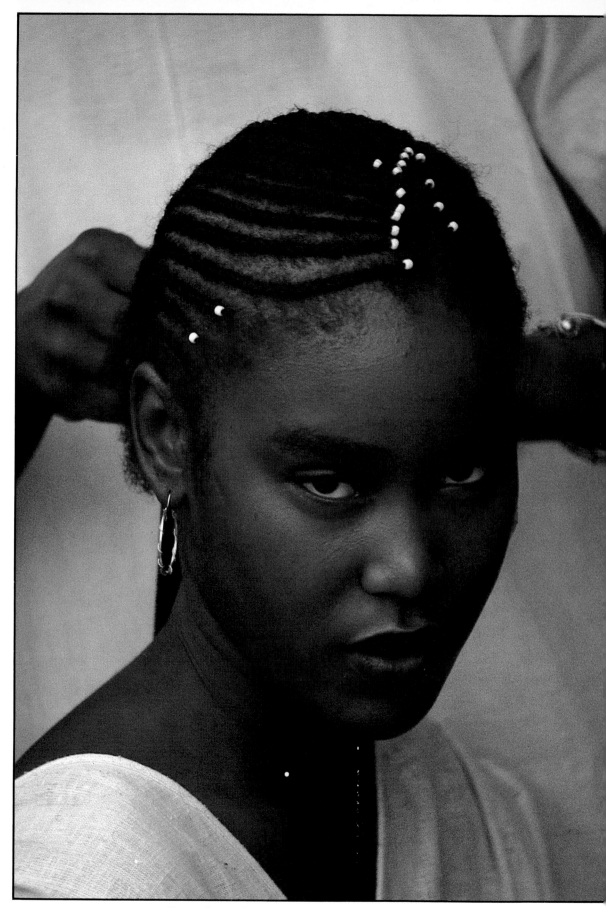

From the earliest days, New Orleans has been related to Afro-Caribbean influences which have affected the city's "soul" and spirit. The recent decades brought to the black community a deep concern for roots and identity. Young people braid their hair as their African ancestors did, and members of

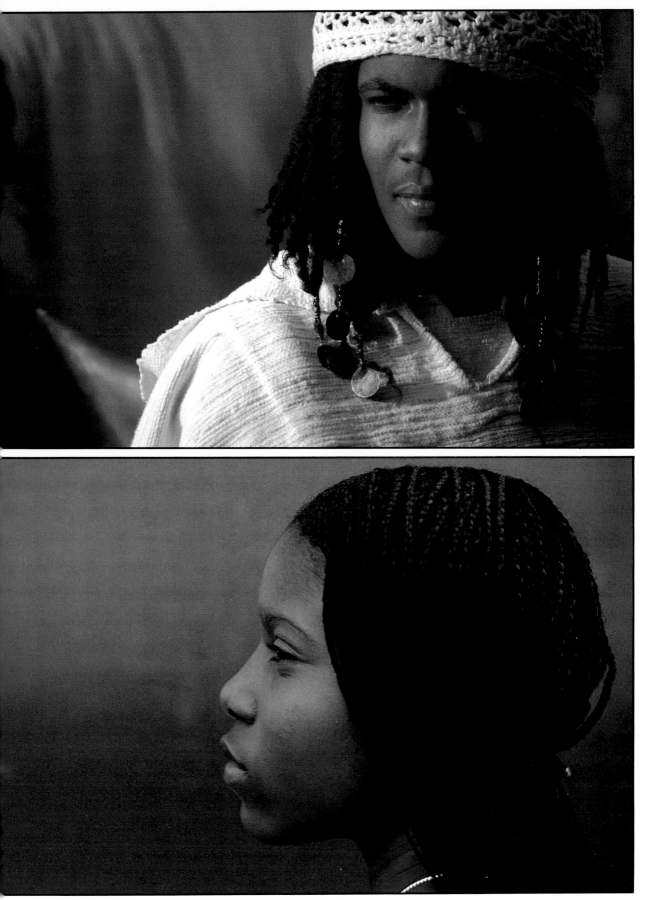

"Nahziriah" community wear African garb while operating as street merchants. Voodoo Queen Marie Laveau is gone, but black mysticism is still reflected in the "Spiritual" churches. And Jazz still expresses the ancient rhythm of its Afro-Caribbean heritage more than anywhere else in the United States.

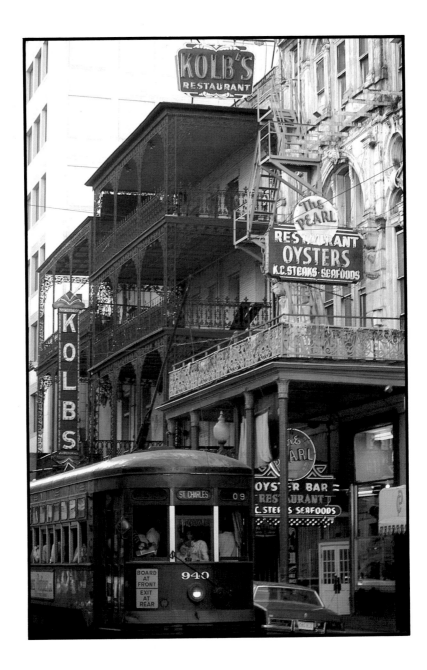

Open to the Seven Seas

As the 19th century dawned, the destiny of the United States lay in Spanish New Orleans. Had New Orleans not been a seaport of supreme importance to the Americans of the Ohio Valley, the expansion of the United States beyond the Mississippi would have been long-deferred.

The use of the port of New Orleans was vital to these upriver Americans. It was much easier and cheaper for them to float their surplus produce down the river to New Orleans for shipment from there to cities of the Atlantic seaboard than it was to cross the mountains.

But Spanish officials in Louisiana refused to grant the Americans the right to deposit their produce duty-free on the levee at New Orleans.

This enraged the Western people, especially the inhabitants of Kentucky. They clamored to the Federal government for relief from an intolerable predicament. In their agitation, they contemplated several rash alternatives. One was to organize a volunteer expedition and seize New Orleans from the Spaniards. Another was to secede from the Union, join Spain and, as Spanish citizens, enjoy the right that was denied them as Americans. A third was to urge the government to send United States troops to New Orleans to "induce" the Spanish authorities to change their minds.

Finally, in 1795, the United States negotiated a treaty with Spain, whereby Americans were granted the free right to deposit their goods at New Orleans for a period of three years. Everything went smoothly during the period of the treaty, and even beyond it, as both the Americans and the Spaniards tacitly agreed to its continuance after it had expired. However, in October, 1802, the Ohio Valley was thrown into a furor again when the Spanish officials at New Orleans suddenly cancelled the right of deposit.

Although it had ceded Louisiana back to France by a secret treaty on October 1, 1800, Spain was still administering Louisiana, when it precipitated the new crisis over the right of deposit at New Orleans.

It was then that President Jefferson, in an historic message to United States Minister Robert R. Livingston in France, stated his foreign policy in the crisis: "There is on the globe one single spot, the possessor of which is our natural enemy, it is New Orleans through which the produce of three-eighths of our territory must pass to market... The day that France takes possession of New Orleans, fixes the sentence which is to restrain her forever within her low water mark... From that moment, we must marry ourselves to the British fleet and nation."

Early in 1803, President Jefferson dispatched James Monroe to France to join Livingston, with instructions to try to purchase New Orleans from Napoleon Bonaparte. What followed was one of the most remarkable sequences of events in American history, the Louisiana Purchase, the "greatest real estate deal" of all time.

What happened was this:

1. Napoleon sold something he had neither the moral nor legal right to sell. He had promised Spain that he would not dispose of Louisiana to another nation if he decided not to colonize it himself. Moreover, under existing French law, he could not dispose of territory without the approval of the two French legislative bodies. Bonaparte had not yet proclaimed himself Emperor of the French; he was still First Consul and, theoretically, at least, was subject to the restraint of law. This he chose to ignore, as he did his promise to Spain.

2. The American ministers, Livingston and Monroe, exceeded their authority by buying all of Louisiana, one-third of the present continental United States, for $15 million or 7.5 times the $2 million they were authorized to spend for the city of New Orleans.

3. President Jefferson, as a strict constructionist of the Constitution, did not feel he had the legal power to accept Louisiana once it had been purchased. He felt that an amendment to the Constitution was necessary to give him this legal power and he actually wrote an amendment to be presented to Congress. Fortunately, Jefferson's advisors talked him out of the idea, protesting that the delay in getting an amendment through Congress and its ratification by the states might cause Bonaparte to change his mind. And so President Jefferson adopted the political doctrine of his Federalist opponents that the Presidency carried with its office broad, implied powers not spelled out by the Constitution. Under this repugnant concept, Jefferson accepted Louisiana.

4. The United States issued bonds to pay the purchase price of Louisiana, but Napoleon, knowing that he was about to renew the war with England, wanted ready cash. And how did he convert the bonds to ready cash? Two British banking houses, Baring and Company of London and its Amsterdam affiliate, Hope and Company, bought the bonds at 18 percent discount, thus providing the First Consul with the money he needed to fight. Patriotism and business did not clash.

Within the space of 20 days in 1803 — November 30 to December 20 — Louisiana was transferred from Spain to France and then from France to the United States. And then the boom set in, as Americans flocked to New Orleans, and to the wide open spaces of the Louisiana

Territory west of the Mississippi. In time the westward push would reach the Pacific, and the United States would achieve its ocean to ocean sweep. All this was made possible by the Louisiana Purchase, which was motivated by the desperate need and the angry demand for the use of the port of New Orleans by the people of the Ohio Valley.

Less than a decade after the American flag was raised over the Place d'Armes — the present Jackson Square — an event that was to usher in a new era in economic development of New Orleans took place. On January 10, 1812, the first steamboat on the western waters reached the city. It was appropriately named "New Orleans." Built and launched in Pittsburgh, the "New Orleans," commanded by Captain Nicholas J. Roosevelt — a relative of two American Presidents — brought astonishment to the people of New Orleans and a new vitality to the already busy port. In half a dozen years, steamboats had become commonplace at New Orleans. On June 12, 1818, the *Louisiana Gazette* stated that "the steamboat ceased to be a novelty..."

The steamboat brought great prosperity to New Orleans, which became the gateway to the Seven Seas for the commerce of the Mississippi Valley. The city grew amazingly and by the time of its 100th anniversary in 1818, its population exceeded 25,000.

The port of New Orleans, and the tremendous flow of commerce in and out of it, paced the city's incredible growth in the decade between 1830 and 1840, when it more than doubled its population, emerging as the third American city to reach 100,000.

Benjamin Moore Norman, in his book *Norman's New Orleans and its Environs* (1845) painted a vivid picture of the bustling riverfront: "...The levee, for the extent of five miles, is crowded with vessels of all sizes, but more especially ships, from every part of the world — with hundreds of immense floating castles and palaces, called steamboats; and barges and flat boats innumerable... The loading and unloading of vessels and steamboats — the transportation, by some three thousand drays of cotton, sugar, tobacco, and the various and extensive products of the great west, strikes the stranger with wonder and admiration... The position of New Orleans, as a vast commercial emporium, is unrivalled — as will be seen by a single glance at the map of the United States. As the depot of the west, and the half-way house of foreign trade, it is almost impossible to anticipate its future magnitude... With such resources nothing short of some dreadful convulsion of nature, or the more dreadful calamity of war, prevent New Orleans from becoming, if not the first, next in commercial importance to the first city of the U.S."

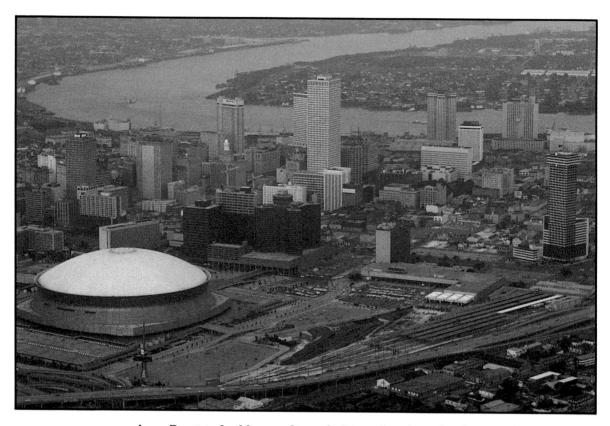

Jean-Baptiste Le Moyne, Sieur de Bienville, chose for the site of New Orleans what he described as "one of the most beautiful crescents of the river." The Mississippi was, and still is, the "raison d'être" for the existence of New Orleans. The small French town on the sweeping crescent and the great modern city that grew up beyond it, bridge the more than two and a half centuries of the port's existence and the city's progress. Without the river there would be no New Orleans. With the river, the city's economic life is vibrant and ever-expanding.

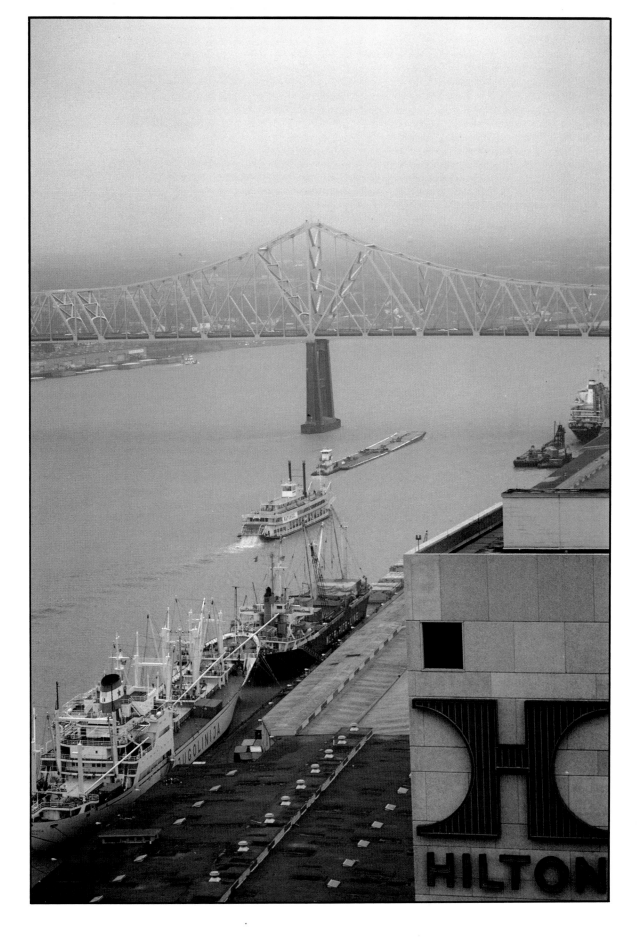

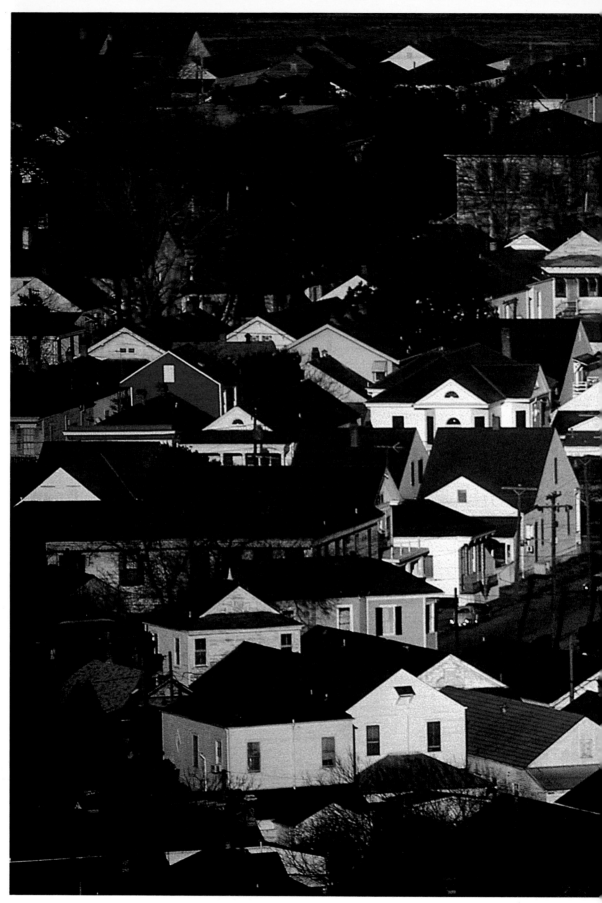

Across the Mississippi from Bienville's crescent where he located his city is a detached part of New Orleans known as Algiers. Why the name? There are several explanations for "Algiers," but there is no certainty as to its origin. There

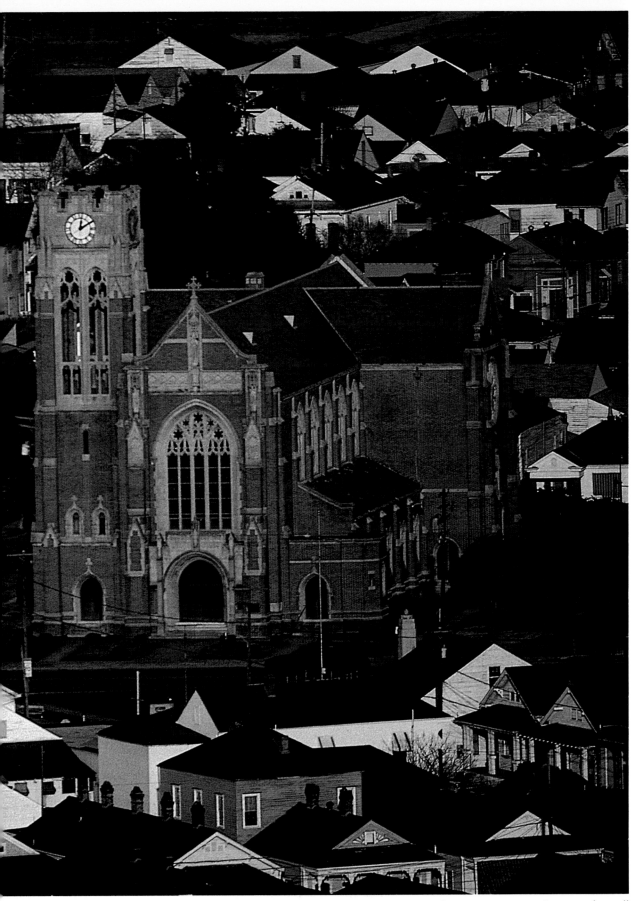

is a United States Naval Station there, but the section is mainly one of small homes. Algiers is reached in a few minutes by a free ferry from the foot of Canal Street or over the Greater New Orleans Bridge.

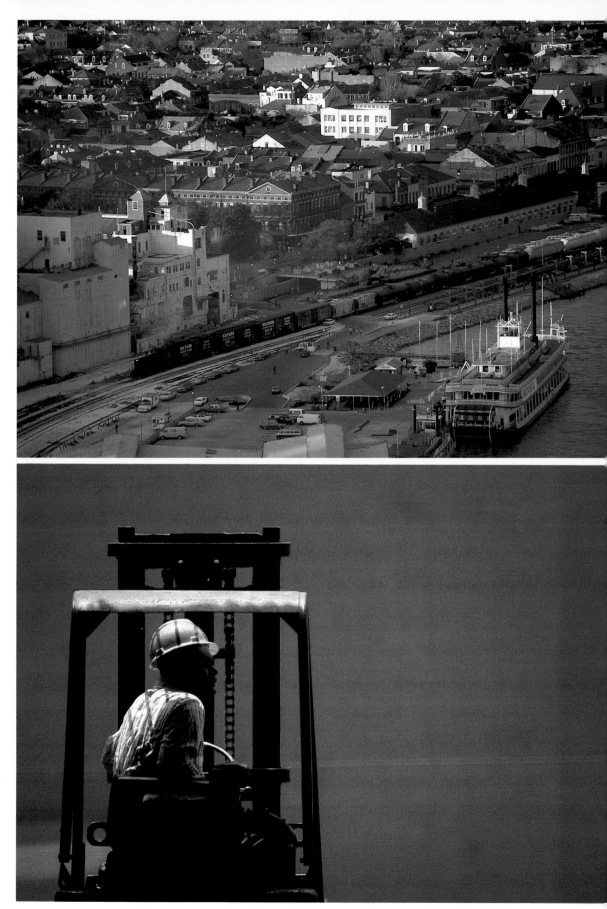

The river front of old New Orleans was alive with activity. Among the forest of masts of ocean-sailing ships were the flatboats and keelboats of the upriver Americans, who brought their produce to Spanish New Orleans in the last quarter of the 18th century. Then came the steamboat in 1812 to American New

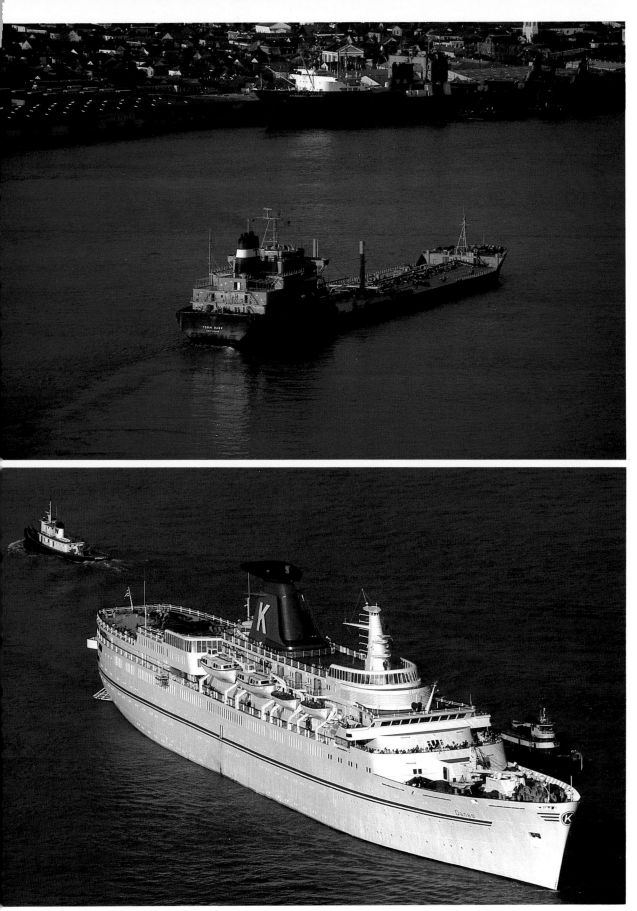

Orleans and a new era dawned. Today, steamboats are only nostalgic excursion vessels and ferries, while the commerce of the river is carried in barges, oil tankers and cargo vessels. It has been estimated that the river yields 60 cents out of every trade dollar in the New Orleans economy.

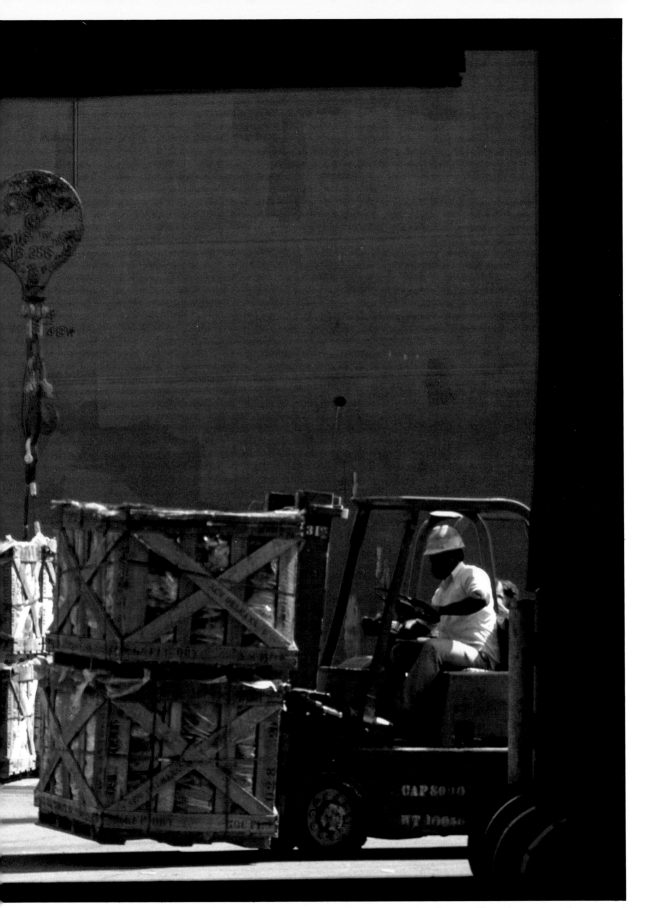

The port of New Orleans, where nearly 5,000 ships call each year, is the second port in the United States, after New York. Its total waterborne commerce annually exceeds 160 million tons. New Orleans ships to the world 38 per cent of all the grain exported from the country, amounting to 1.5 billion bushels.

Railroad facilities, which bring freight cars and "piggyback" trucks to dockside, play a significant role in the functioning of the port of New Orleans. The primary hinterland served by the port includes more than a dozen states, mainly in the Mississippi Valley. This covers more than one fourth (27 per cent) of the total square miles of the United States, all of which is linked to the port by the railroads.

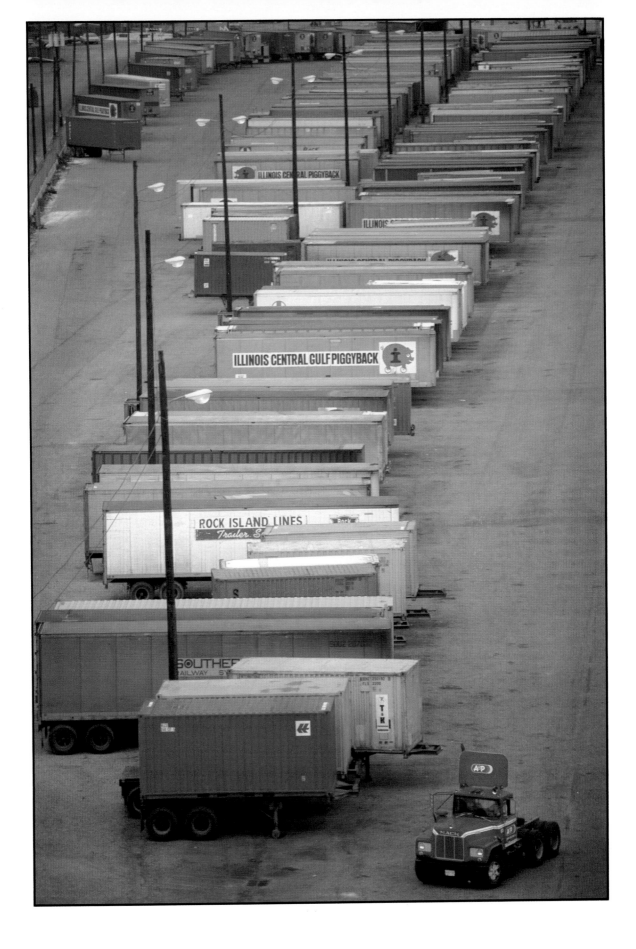

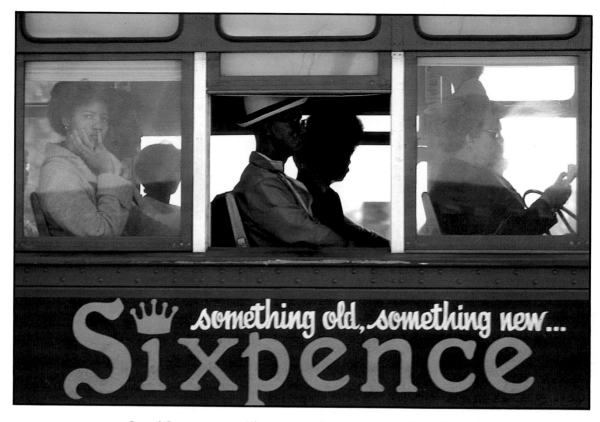

Canal Street, named for a canal that never was dug, divided the old French city from the new American town which sprang up after the Louisiana Purchase in 1803. It extends on a straight line for about three miles from the river, terminating at a group of cemeteries. On Canal Street is the traditional shopping area of New Orleans, still surviving in an age of suburban shopping centers. Once, dozens of street car lines ran to and from Canal Street, operating on the "neutral ground" in the center of the 171-foot wide thoroughfare. This area was reserved for the never-dug canal. The only remaining street cars in the United States, other than San Francisco's cable cars, the St. Charles line loops into Canal Street from Carondelet Street and out of it into St. Charles Avenue, a block away, as it heads for uptown residential New Orleans.

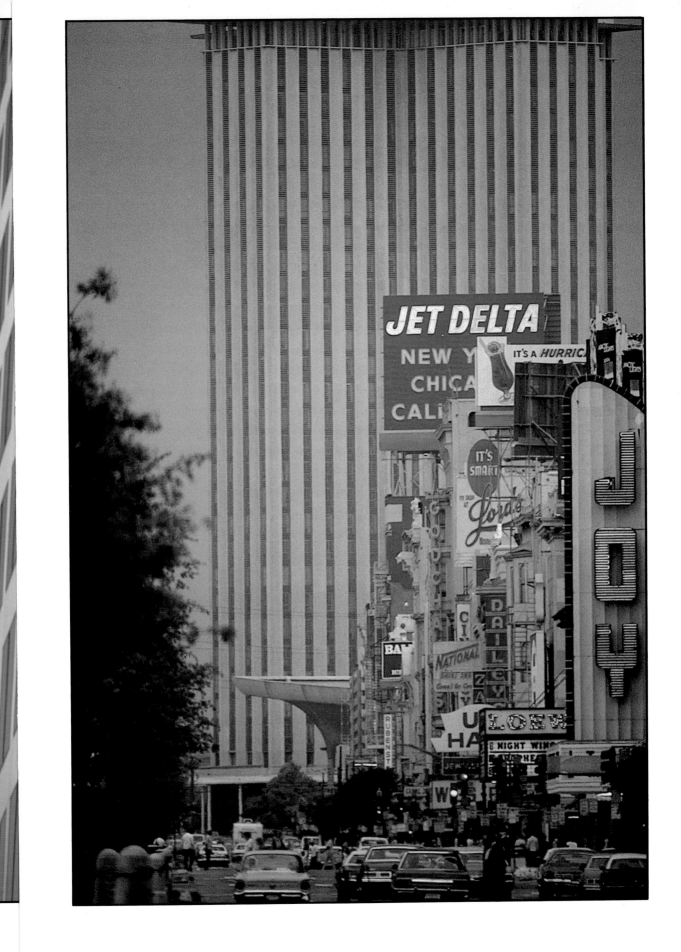

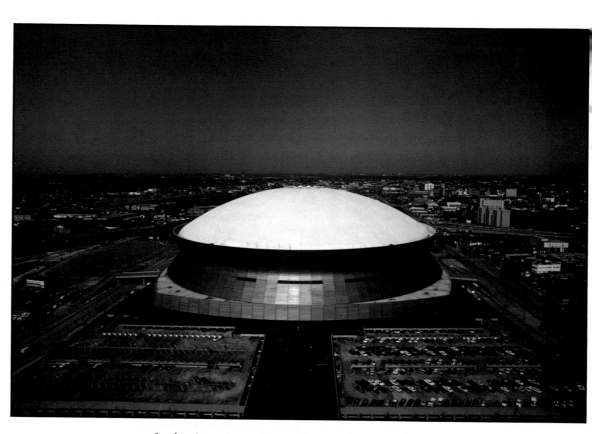

In the American city, modern architecture has its boldest expression in the Louisiana Superdome. This circular, multi-purpose structure, 27 storeys high, seats 76,000 for football and can accomodate more than 96,000 on special occasions. Its dome, covering an area of 9.7 acres is 273 feet above the surface level. Its cost exceeded $163 million, or almost 11 times what the United States paid for the Louisiana Purchase in 1803. From the Superdome to Canal Street, the business district, heavily-populated by day, is almost deserted by night.

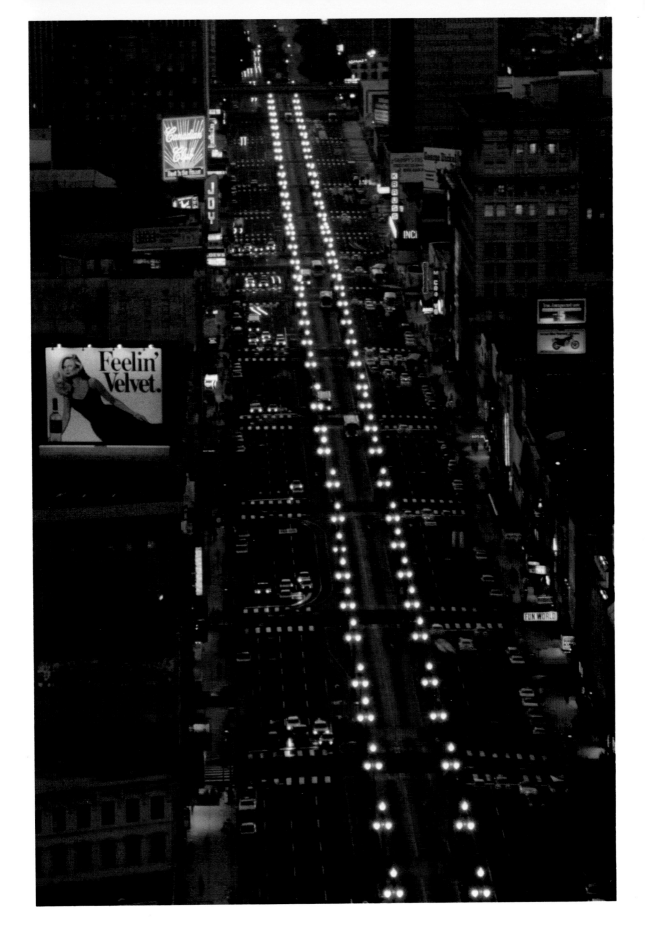

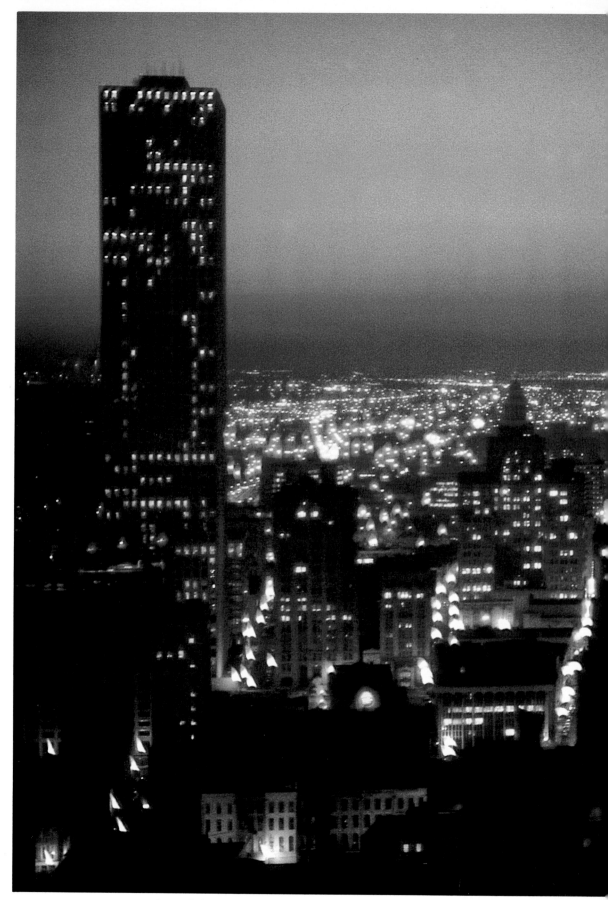

*New Orleans, some areas of which are below sea level, sprawls between the
Mississippi River and Lake Pontchartrain. If one stands on
the observation deck of the International Trade Mart at sunset,
the view of the American city presents a fairyland of light, natural and artificial.*

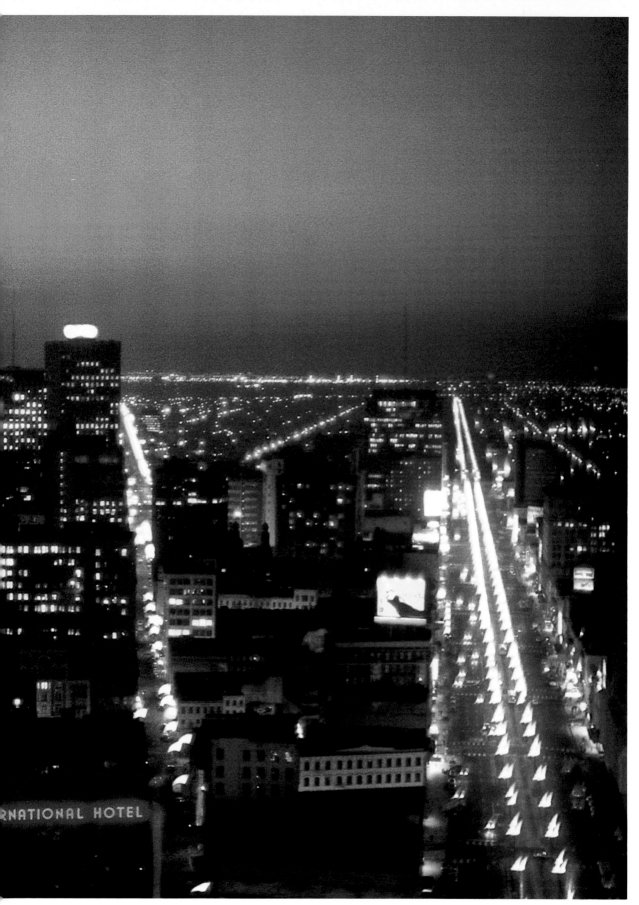

RNATIONAL HOTEL

*Back of the viewer is the river, while in the distant front is the lake.
To one's left is uptown New Orleans — "uptown" means up the river —
and to the right of Canal Street is the Vieux Carré
and downtown (down river) New Orleans.*

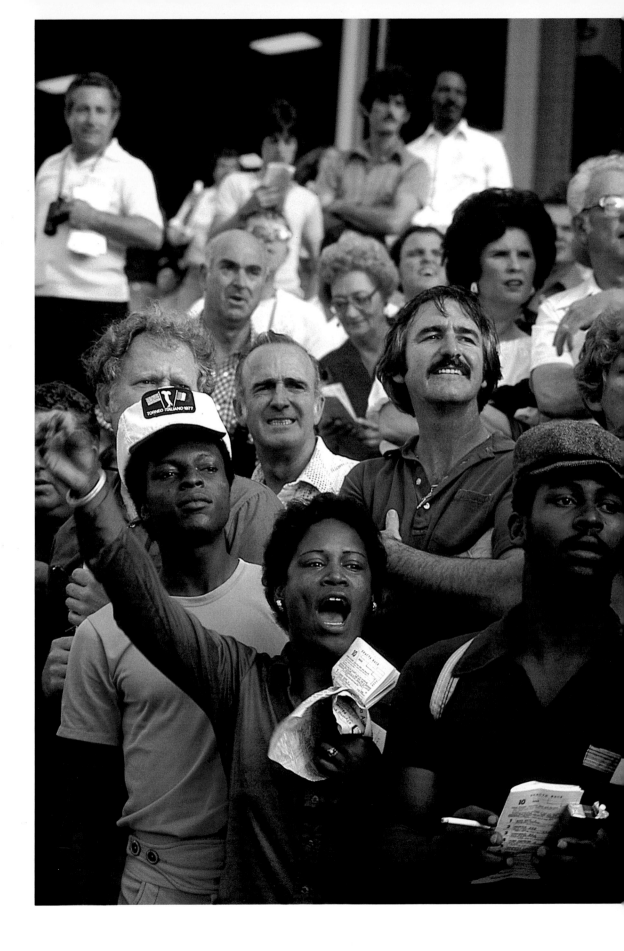

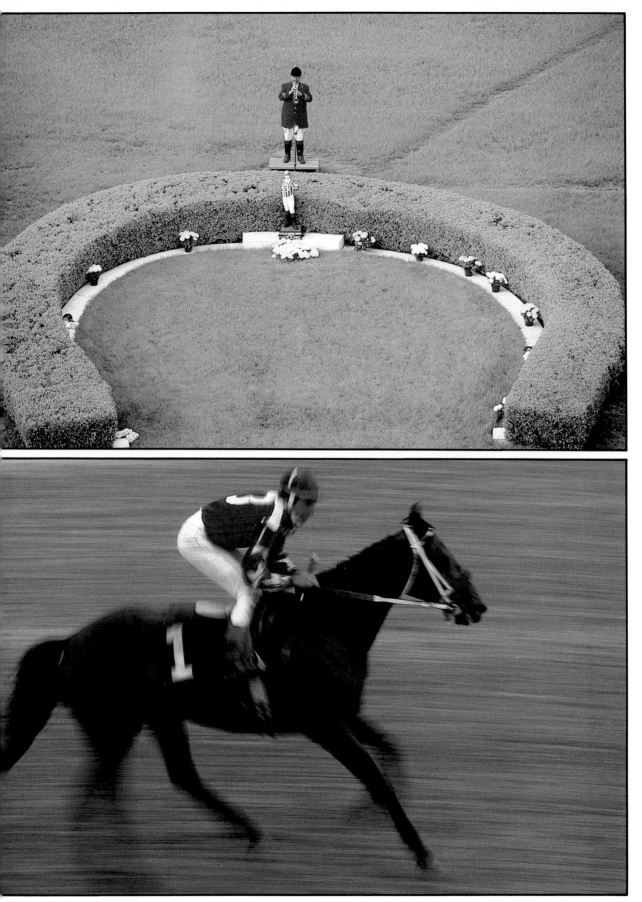

Horse racing, popular all over the United States from the earliest days, was a favorite pastime of the Creoles of New Orleans. The nation's third oldest racecourse — but the oldest in the Deep South — is the Fair Grounds, where thoroughbred meetings have been held for more than a century.

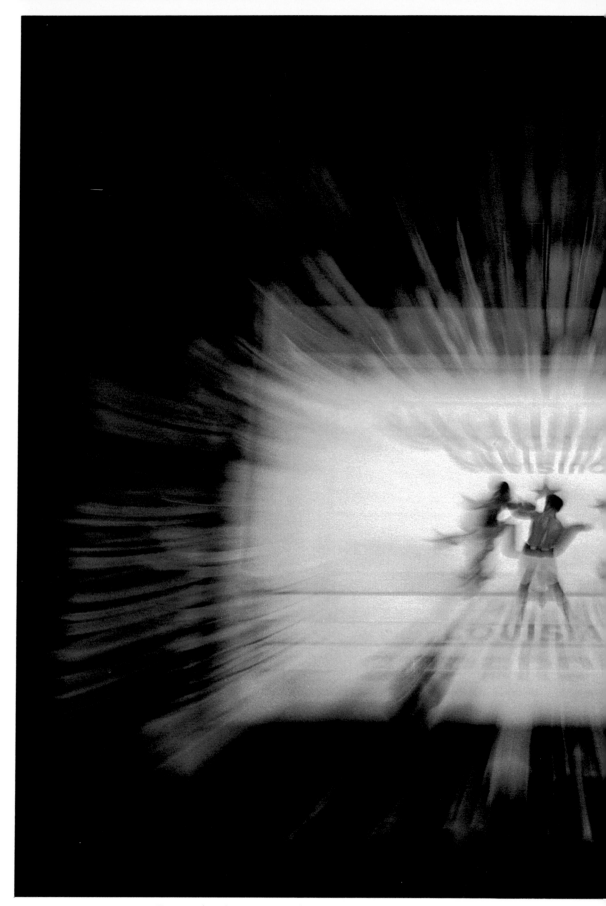

82

*Boxing has been a popular sport in New Orleans since before the Civil War.
Here, at the Olympic Club in 1892, "Gentleman Jim" Corbett
knocked out John L. Sullivan to win the World's Heavyweight*

Championship in the first heavyweight title bout fought under the Marquis of Queensberry rules. Today, the boxing tradition is continued in the Superdome, where championship matches have been staged.

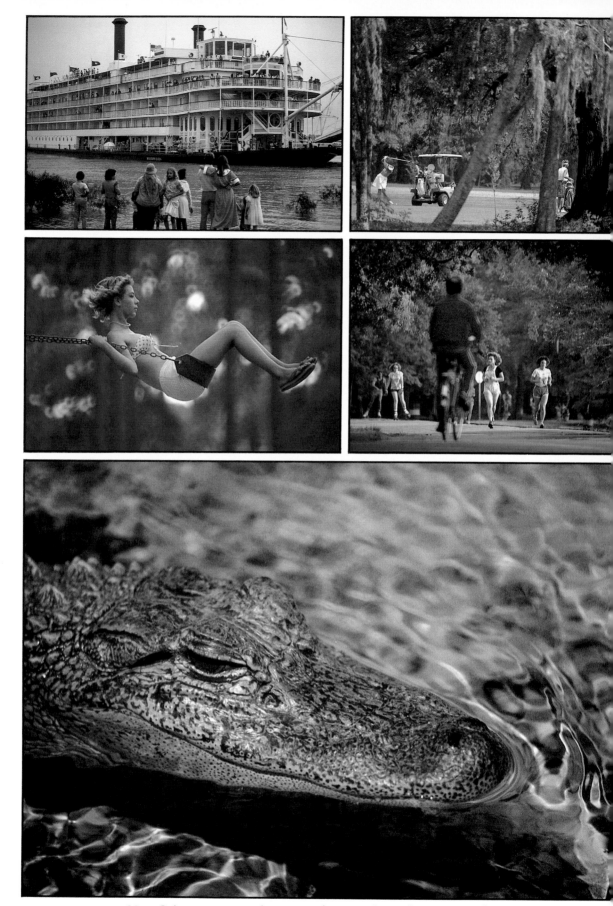

New Orleans is an outdoor city whose parks and recreational areas are enjoyed by the people almost every day in the year. Occasionally, denizens of the swamps, such as alligators, will find their way into park lagoons. But young and old may see alligators in the Audubon Park Zoo, any day of the week.

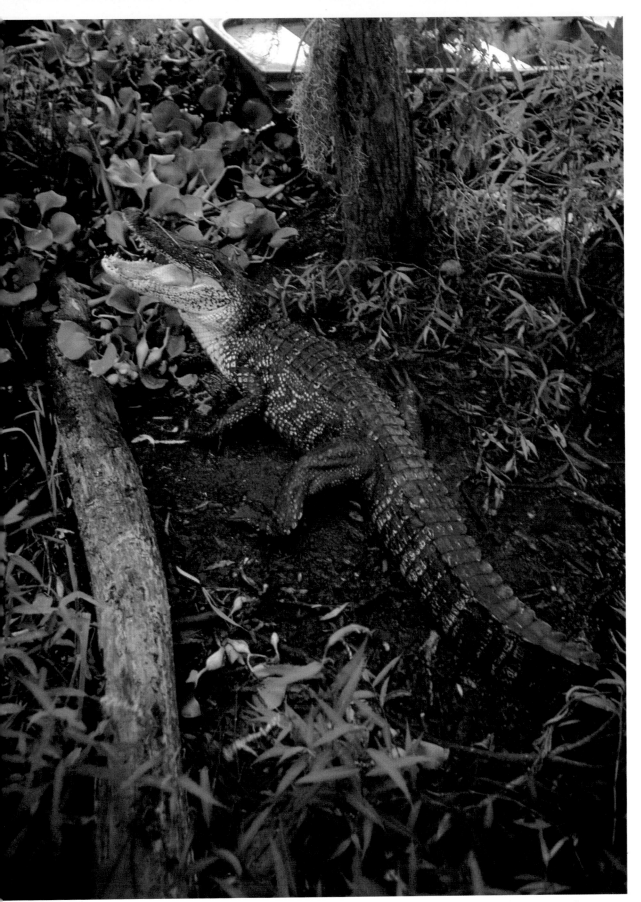

Within the city limits, an area of 365 square miles, there are woods and swamps where alligators may be hunted when the Louisiana Wild Life and Fisheries Commission declares an open season on the species.
Here a eight-foot alligator, having taken the baited hook, furiously struggles to free itself from the line. The gun of the hunter ends the fight.

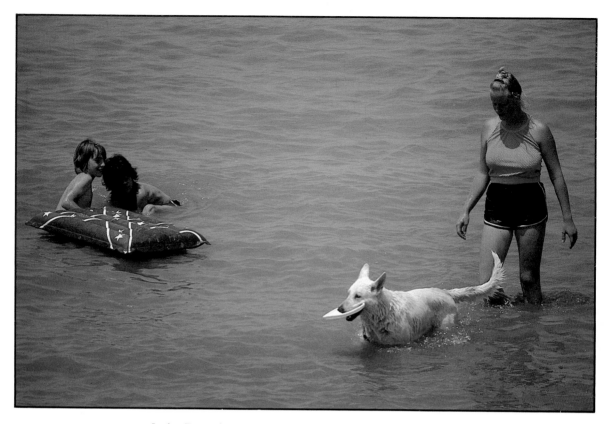

Lake Pontchartrain is the most important recreational area in New Orleans. Thousands flock there for year-around yachting, fishing, crabbing and, in the warm months of spring, summer and autumn, for water-skiing, wind-surfing, swimming, sun-bathing, picknicking. Named for the French Minister of Marine when Louisiana was settled, Lake Pontchartrain is 40 miles long and 26 miles wide and has an average depth of less than 12 feet.

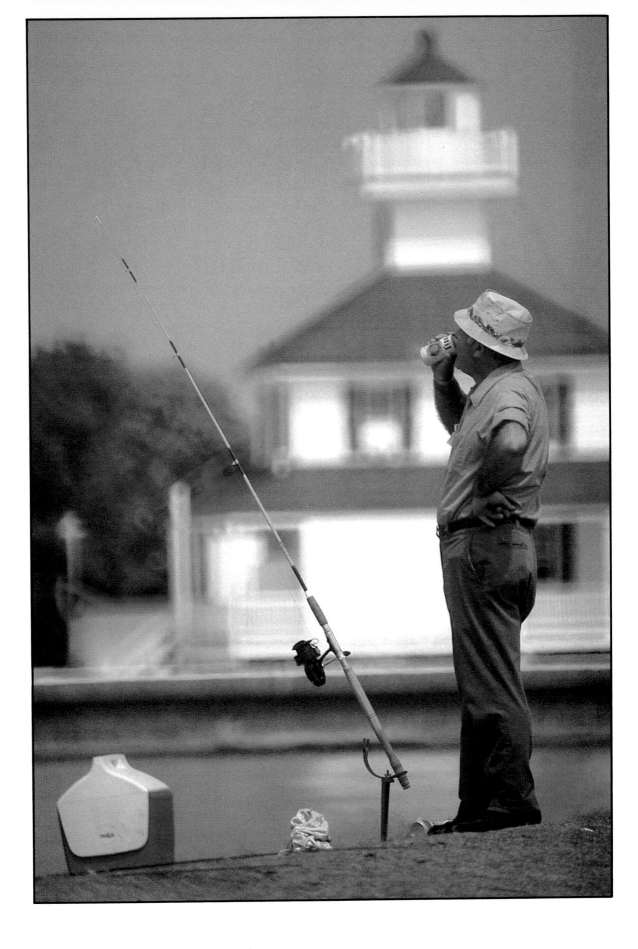

Although New Orleans is a great port, it is more than 100 miles from the Gulf of Mexico, so its "sea" is Lake Pontchartrain. Here is located the Southern Yacht-Club, the second oldest in the United States, from among whose skilled sailors have come national, international and olympic champions. In the distance may be seen the Lake Pontchartrain Causeway, the longest concrete bridge — actually, twin bridges — in the world, with a length of more than 23 miles. As with so many other recreational areas in our industrial age, the lake is threatened with pollution and sometimes health authorities warn against swimming.

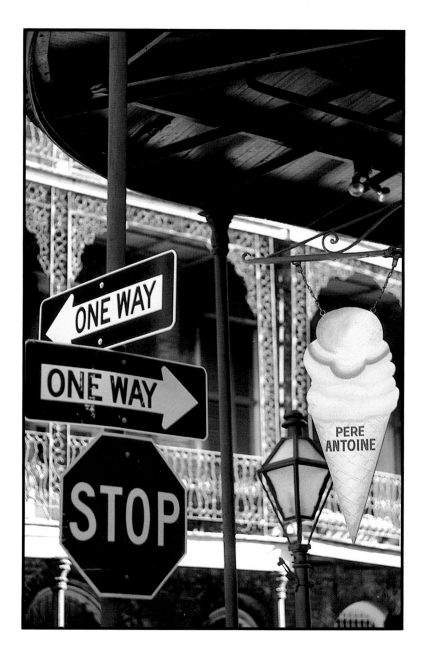

Old World City

New Orleans was "born" in an undated resolution passed by the directors of John Law's Company of the West in Paris some time in September 1717. The resolution read: "Resolved that they will establish thirty leagues up the river, a town which they will name New Orleans, which one may reach by the river and by Lake Pontchartrain."

On October 1, 1717, the Company of the West appointed a cashier and warehouse-keeper for "the commercial office which is to be established at New Orleans." The city, which existed only on paper, was named for Philip, Duke of Orleans, who was regent for the child-king, Louis XV.

It was not until the following spring, sometime between March 15 and April 15, 1718, that Bienville began the establishment of New Orleans, where the canebrakes crowded close to the Mississippi on the crescent in the river he had found so beautiful. It was a low, swampy site and far from an ideal spot to plant a city, but what disadvantages it had, and there were many, were outweighed by the proximity of the river and lake at this point.

Bienville, according to a contemporary account, "cut the first cane... and tried to open a passage through the dense canebrakes from the river to the place where the barracks were to be... The whole locality was a dense canebrake..."

What is today known as the Vieux Carré, or French Quarter, was laid out in 1721 by the engineer, Adrien de Pauger. Up to Pauger's survey of the streets and squares, New Orleans was a haphazard collection of huts, as Father Charlevoix discovered in January, 1722. "Here I am, finally arrived in the famous town which has been named New Orleans," wrote the Jesuit missionary, "...This town is the first that one of the world's greatest rivers has seen rise upon its banks. But the eight hundred fine houses and the five parish churches that *Le Mercure* attributed to it two years ago are reduced today to a hundred huts placed without much order, a large warehouse built of wood, two or three houses that would not grace a French village, and half a wretched warehouse that they had been good enough to lend to the Lord and of which He had hardly taken possession than they wanted to put Him out to lodge Himself under a tent..."

Father Charlevoix then made this prediction for New Orleans: "This savage and deserted place, which the canebrake and trees cover almost entirely will one day, and perhaps that day will not be distant, be a

wealthy city and the metropolis of a great and rich colony."

It took a hurricane, which struck on September 11, 1722, to remove the buildings which were out of alignment with the city Pauger had surveyed. Chief Engineer Le Blond de la Tour described this as the "most terrible tempest and hurricane that could ever be seen." Two-thirds of the houses were destroyed and the rest so damaged that they had to be torn down. "All these buildings," reported de la Tour, "were old and provisionally built, and not a single one in the alignment of the new city and thus would have had to be demolished. Thus there would not have been any great misfortune in this disaster except that we must act to put all the people in shelter."

Pauger's New Orleans, although many of its squares were unimproved, comprised today's Vieux Carré or Old Square. As the 18th century progressed, the empty squares acquired buildings. By the time the Spanish regime began in New Orleans in the mid 1760s, the entire area between the river and Rampart Street, and between Iberville Street and Esplanade Avenue was completely built up.

Spain, naturally, inherited a French city, but when it turned New Orleans back to France in 1803, it was almost a completely rebuilt Spanish town. It is ironic that what New Orleans calls the French Quarter was built by the Spaniards and later, during the American domination. As a consequence of two disastrous fires within six years late in the 18th century, the French Quarter has only one authentic French colonial building remaining. This is the Ursuline Convent at 1114 Chartres Street, completed about 1751. This is believed to be the oldest building in the Mississippi Valley.

The first fire came on Good Friday in 1788. Governor Estaban Miró reported: "In the afternoon of March 21st last, at one thirty, the residence of the Army Treasurer Don Vincente José Nuñez caught on fire, reducing to ashes eight hundred and fifty buildings, among which are all the business houses and the residences of the most aristocratic families." The Nuñez house, where the fire started, was located at what is now 619 Chartres Street.

The city had hardly been rebuilt after the 1788 blaze, when fire again devastated the city on December 8, 1794. It started in a private residence at what is now 534 Royal Street and spread rapidly. Fewer buildings were destroyed in the second fire than in the first, but the financial loss in 1794 was greater than the $2 million loss in the fire of 1788. Following the second fire, the authorities passed rigid building laws, among them one requiring that "all two story houses… should be

constructed of brick or of timber frames filled with brick between the upright posts, the timbers to be covered with cement at least one inch thick, roofed with flat roofs of tile and brick." Provided they were no deeper than 30 feet, single story houses of wood were still permitted.

A distinguished architectural historian, Samuel Wilson Jr., in an authoritative monograph on the Vieux Carré, states:

"The Vieux Carré, in its architectural character today, is the result of two and a half centuries of growth, reflecting the influence of changing times and diverse nationalities. While little remains of the buildings of the French colonial period, the influence of the French cultural background of much of the population continued to be felt in building style and technique well into the nineteenth century. Much that the early French developed was carried on, adopted or modified by subsequent Spanish and American settlers."

The heart of the Vieux Carré is Jackson Square, the Place d'Armes of the French, the Plaza de Armas of the Spanish. It is one of America's most notable architectural ensembles, with St. Louis Cathedral, flanked by the Cabildo on one side and the Presbytère on the other, facing the river, and the matching Pontalba Buildings on the other two sides of the square. A church has existed on this site since 1727. The present cathedral, dating from 1851, replaced a venerable and much-loved church built by the wealthy Spanish official Don Andrés Almonester y Roxas. He also built the Cabildo and Presbytère, house of the clergy, and it was his daugher, Micaela, Baroness Pontalba, who built the handsome buildings that bear her name.

Jackson Square — the Americans called it the Public Square, until it was named in 1851 for Andrew Jackson, hero of the Battle of New Orleans — is one of America's most historic spots. Under both the French and Spanish, troops drilled and paraded here, and here public decrees were read and posted, and visiting dignitaries were received. It was here that Alexander O'Reilly, the "Irish Spaniard" landed his formidable force of 2,600 men to suppress the Revolution of 1768 and firmly establish Spanish rule in Louisiana. And it was here that the tricolor of the French Republic replaced the flag of Bourbon Spain on November 30, 1803, and waved in the breeze for 20 days, before it was replaced by the American flag on December 20.

After he had defeated the British at Chalmette, below the city in 1815, Jackson was triumphantly received in the square. Twenty-five years later, after he had served two terms as President, Jackson returned to New Orleans to lay the cornerstone for a future monument to be

erected in his honor. The equestrian statue by Clark Mills was dedicated on February 9, 1856, and among the speakers was the sculptor himself who told the throng, estimated at 60,000 persons:

"The statue before you represents one who, with a handful of men, proved himself the savior of your beautiful city."

Andrew Jackson and his rearing horse — replicas of the statue are in Washington and Nashville — reportedly weigh 10 tons. According to a contemporary account, the statue was created "on a new principle, which was to have the hind legs of the horse exactly under the center of the body which, of course, produced a perfect balance, thereby giving the horse more the appearance of life." Of Mills and his statue, the noted critic Lorado Taft said: "He never had seen an equestrian statue; there was none in this country to see. It seems at first strange that America's initial performance in this line should be an attempt of surpassing audacity, but it is the story of all beginnings... At any rate, he built a colossal horse, adroitly balanced on its hind legs, and America gazed with bated breath. Nobody knows or cares whether the rider looks like Jackson or not; the extraordinary pose of the horse absorbs all attention, all admiration."

Celebrations in Jackson Square were held for the Marquis de Lafayette in 1825, for General Zachary Taylor in 1847 and for President Charles de Gaulle of France in 1960. President Dwight D. Eisenhower attended the reenactment of the Louisiana Purchase transfer there in 1953 and many of the ceremonies connected with the 150th anniversary of the Battle of New Orleans in 1965 were held in Jackson Square.

Today, Jackson Square is the No. 1 tourist attraction in the Vieux Carré, for its architectural charm and its access to the Moon Walk, with its fine view of the Mississippi River. Just a few steps across from Jackson Square is the famed Café du Monde, where coffee and doughnuts — they're really beignets, not doughnuts — are available around the clock, around the calendar. This coffee-house is in the historic old French Market, which by reason of recent over-restoration, has lost some of its picturesque character. A perceptive architectural historian, Bernard Lemann of Tulane University, anticipated this when he wrote: "The French Market area will present certain problems: how to retain and cultivate the present array of unselfconsciously colorful shops — Italian groceries and bakeries, importers, hardware merchants, feed and seed stores — and at the same time protect the buildings from neglect... Rehabilitation can so easily divest a neighborhood of its vitality and character."

Among the distinctive features of the Vieux Carré buildings are the cast iron ornamental balconies, which became popular in ante-bellum New Orleans. The two Pontalba Buildings at Jackson Square have the French Quarter's finest iron work. Throughout the area cast iron galleries, verandahs, grilles, gates and fences abound. Another Vieux Carré "specialty" is the patio filled with shrubs and flowers.

Mark Twain, in "Life on the Mississippi," recorded what he considered a unique characteristic of the Vieux Carré: "The houses are massed in blocks; are austerely plain and dignified; uniform of pattern, with here and there a departure from it with pleasing effect... Their chief beauty is the deep, warm, varicolored stain with which time and the weather have enriched the plaster. It harmonizes with all the surroundings, and has as natural a look of belonging there as has the flush upon sunset clouds. This charming decoration cannot be successfully imitated; neither is it to be found elsewhere in America."

After the Civil War, many of the Creole families left the Vieux Carré and by the early years of the 20th century it had declined and stagnated. As early as 1887, the critic Charles Dudley Warner sensed this: "The French Quarter is out of repair... and although it swarms with people, and contains the cathedral... the French Market, the French opera house and other theaters, the Mint... old banks, scores of houses of historic celebrity, it is a city of the past, specially interesting in its picturesque decay."

Bourbon Street, once as refined as any other street in the Vieux Carré, is the "strippers' strip." The end of Storyville, the restricted district along Basin Street, in 1918, led to the rise of Bourbon Street as the mecca of the night-life set. To some, Bourbon Street is *the* French Quarter. To others, Bourbon Street — rowdy, raucous, tawdry, tinselled — is an abomination.

In the early 1920s, the Renaissance of the French Quarter began. Newcomers to New Orleans acquired homes at a fraction of what they are worth today and began to restore them. Orleanians, too, joined in the rehabilitation of the Vieux Carré. In 1936, the Legislature passed an act creating the Vieux Carré Commission which a municipal ordinance in 1937 charged with preserving the French Quarter's "quaint and distinctive character." Affective watchdogs in the preservation of the French Quarter are such groups as Vieux Carré Property Owners, Patio Planters, Louisiana Landmarks Society and Friends of the Cabildo.

There is a constant struggle between preservation and progress, but as long as preservation survives, the Vieux Carré will be an Old World city within a city.

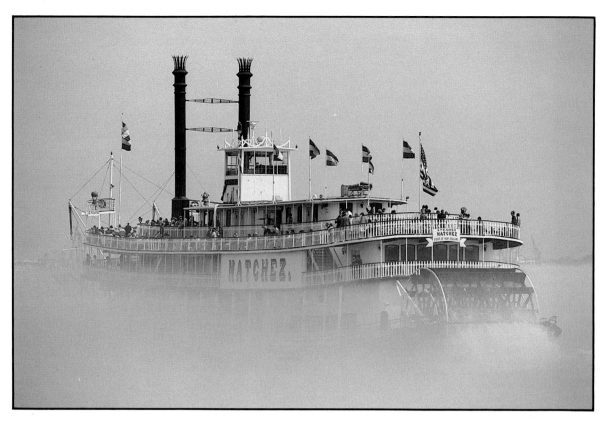

*Visitors are always eager to see the Mississippi and there is
no better place to view it than from the Moon Walk in front of Jackson Square,
the Place d'Armes of the French, Plaza de Armas of the Spanish,
the military parade grounds. Excursion steamers depart from this point,
the heart of Bienville's "beautiful crescent," where he built his city.*

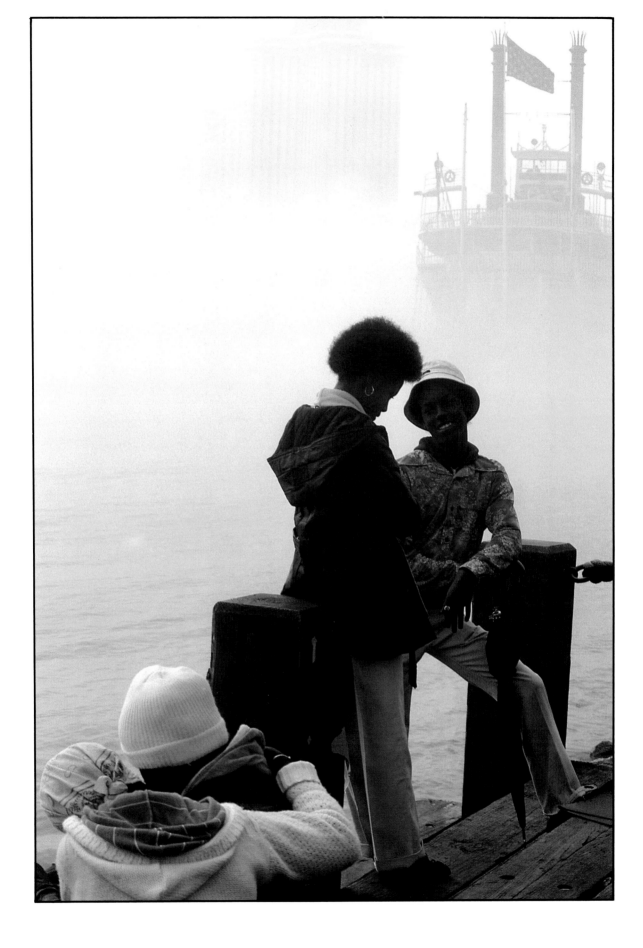

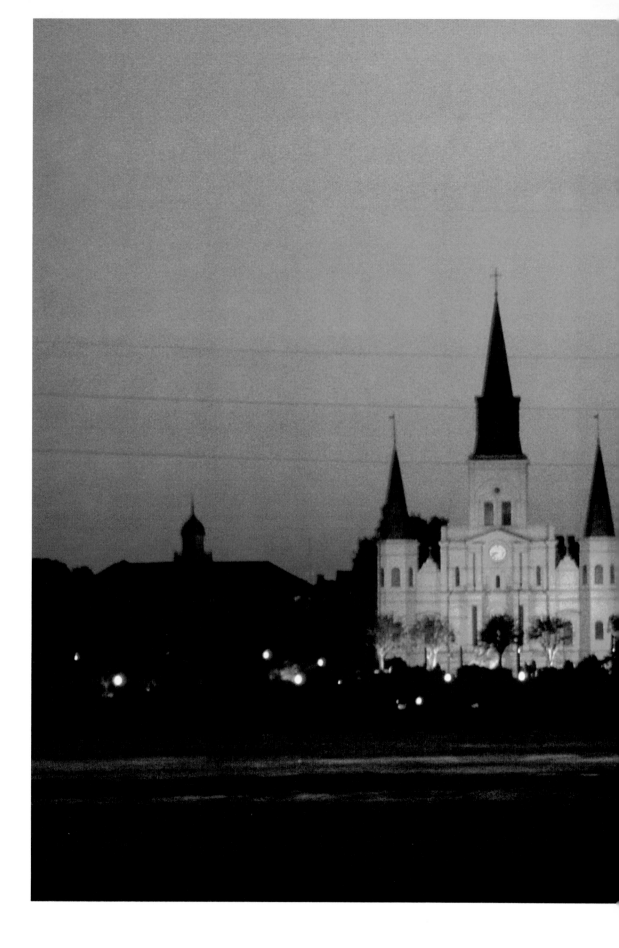

No more picturesque "postcard" view exists in America than Jackson Square, dominated by St. Louis Cathedral. Built in 1850, on the site where a church has existed since 1727, the Cathedral has seen sailing vessels, steamboats, passenger liners and cargo ships pass by on the muddy Mississippi. Times change, customs vary, styles differ, but Old Man River keeps rolling along.

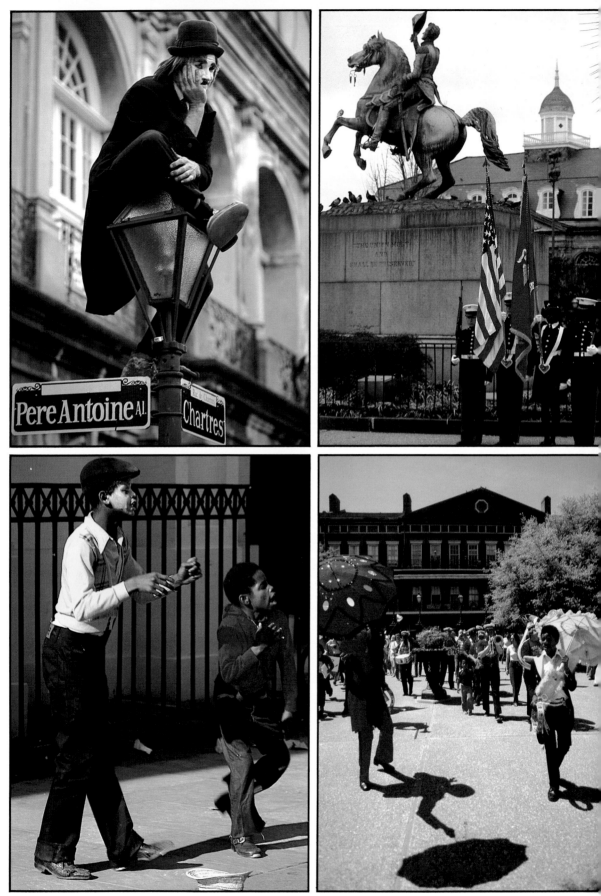

*Heart of the original city, where past and present meet,
Jackson Square is flanked on three sides by historic buildings. The square is
named for Andrew Jackson, hero of the Battle of New Orleans, frozen in bronze
on his rearing horse, saluting the city he saved from the British in 1815.*

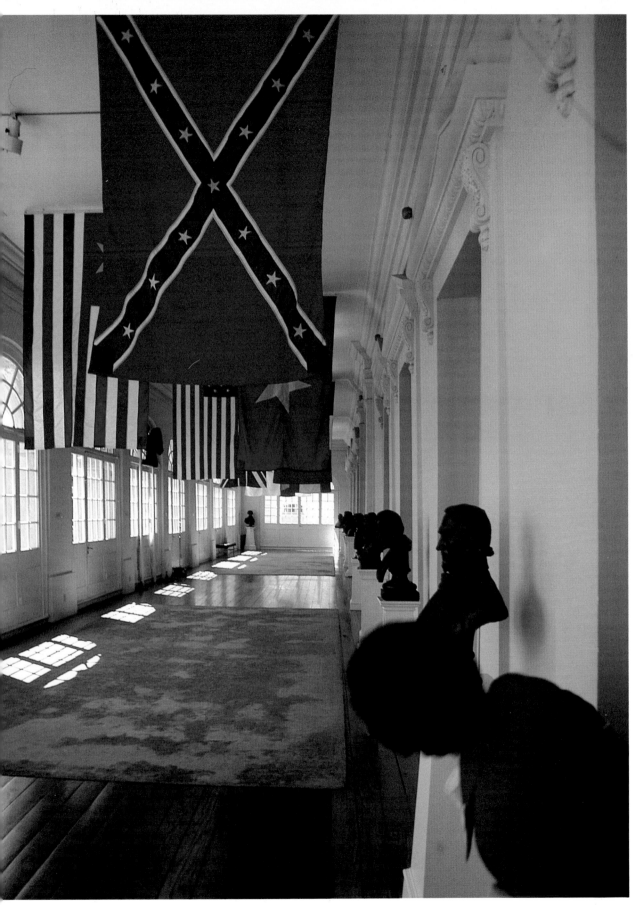

The square is alive with strollers, tap dancers, mimes, musicians. Sometimes, military color guards recall that the flags of Spain, France and the United States all flew here within a period of 20 days in 1803. In the Cabildo, adjacent to the Cathedral, the double-transfer of Louisiana took place.

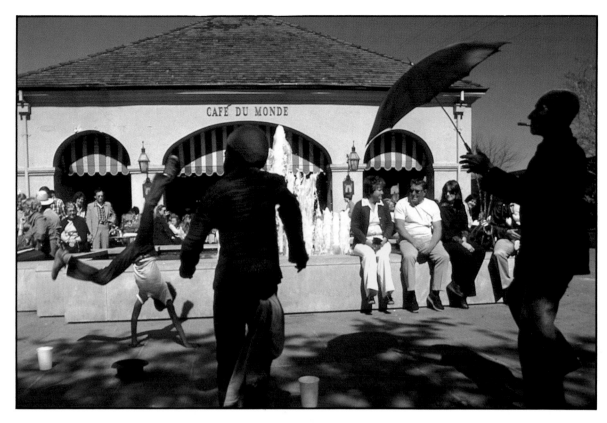

A few steps from Jackson Square is the Café du Monde, where coffee and doughnuts have been dispensed around-the-clock and around-the-calendar for decades. The doughnuts are not doughnuts at all, but a "holeless" confection that the French call beignets. Nearby is the stand for the horse-drawn carriages of ancient vintage which take visitors on tours of the Vieux Carré.

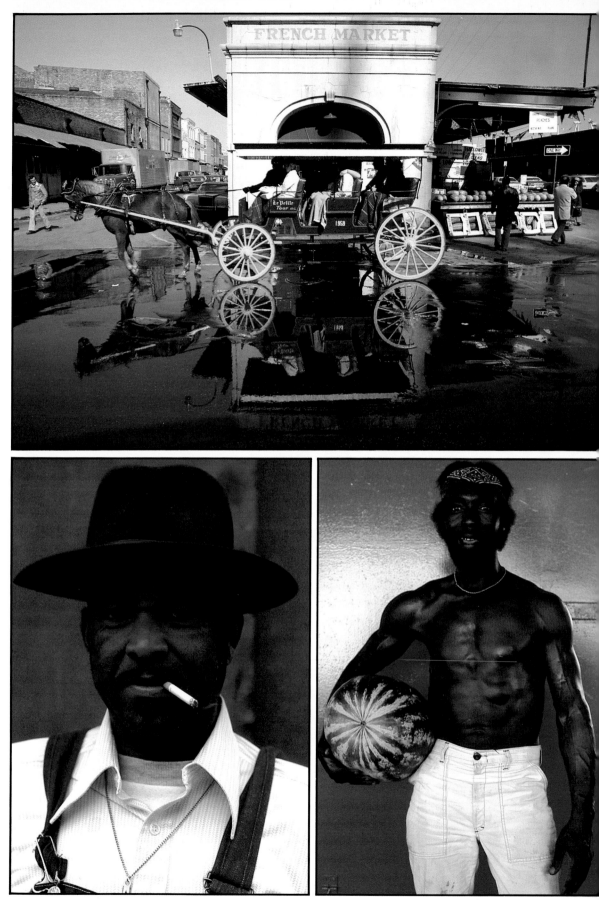

The oldest "trading post" in the city is the French Market, where Choctaw Indians from across Lake Pontchartrain first came to sell their produce to the people of the Vieux Carré. Here, since early days, were sold fruit, vegetables,

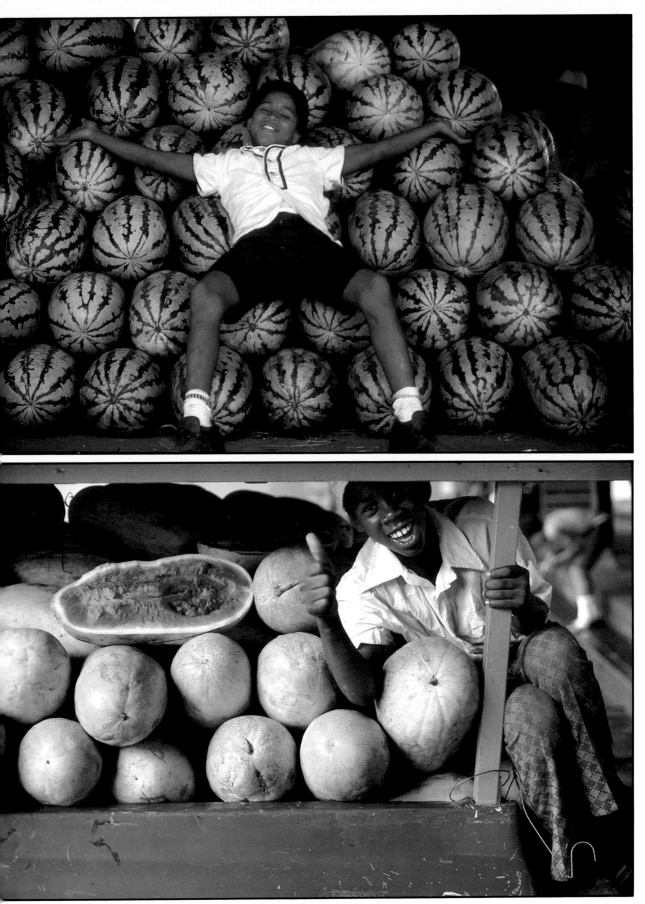

fish, shrimp, crabs and all other ingredients of the inimitable Creole cuisine for which New Orleans is famous. Vendors once cried their wares in song, time has eliminated the bedlam of voices, except among those who unload watermelons.

The Vieux Carré Commission, created by the Louisiana Legislature, is charged with the preservation of the historic architecture of the French Quarter. Atmosphere is preserved by French and Spanish street names, buildings with wrought-iron and cast-iron grill work, the origin of which stems from the Spanish regime in New Orleans.

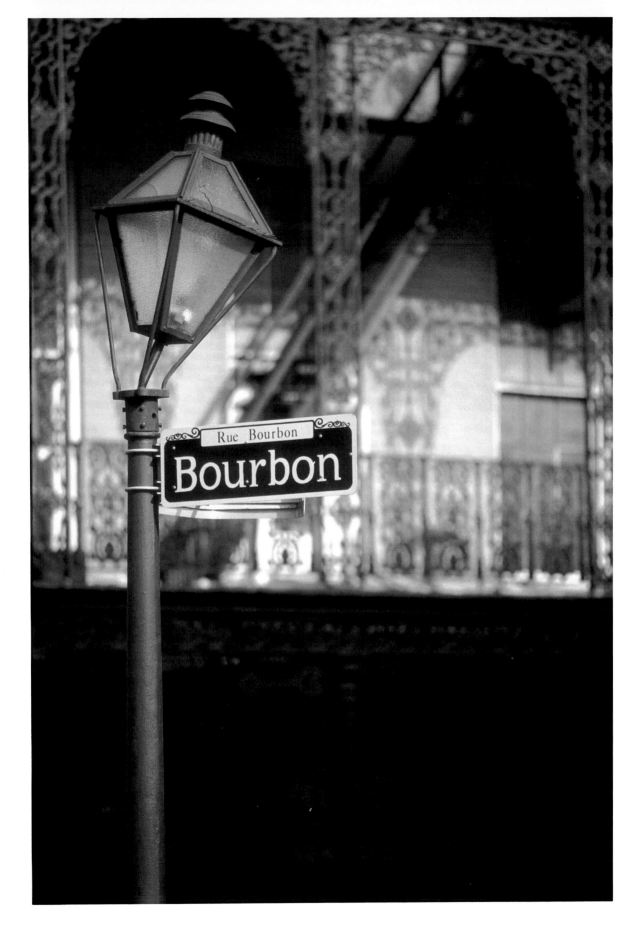

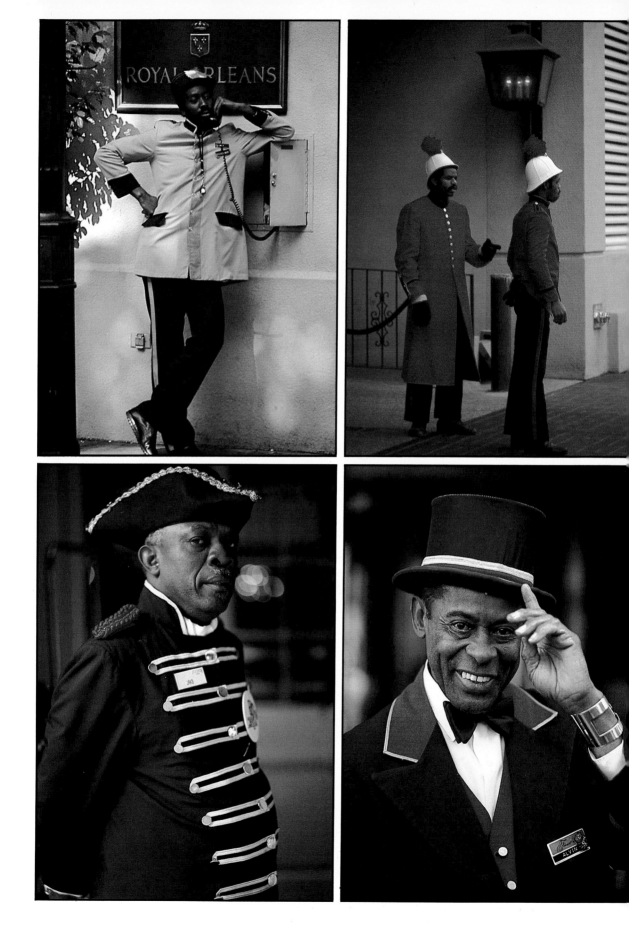

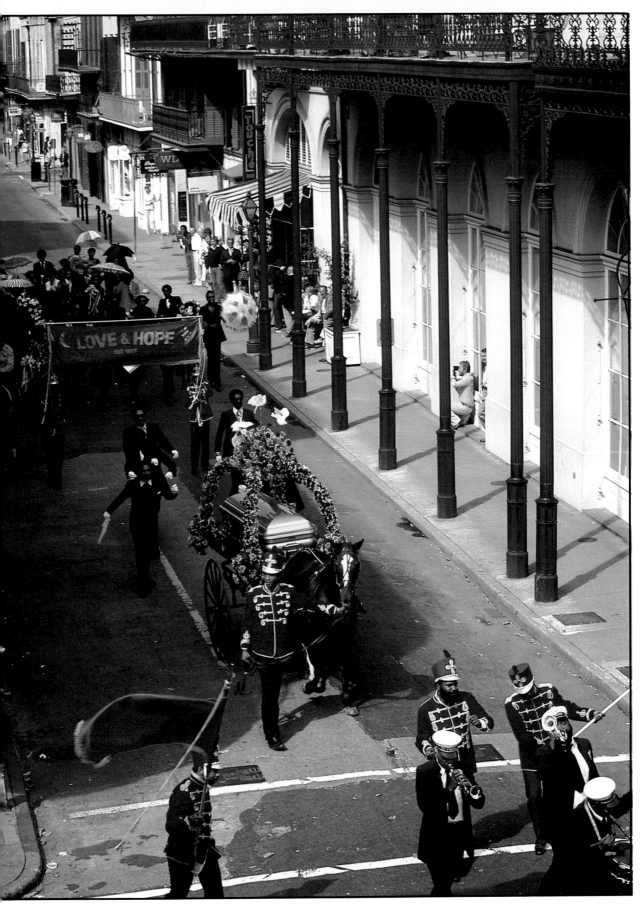

*Long ago, the combination of architecture and atmosphere in the Vieux Carré,
made it attractive to Hollywood moviemakers. Hotel doormen, picturesquely
garbed in 19th century fashion, could move easily from their posts into scenes
such as this movie funeral parade on Royal Street.*

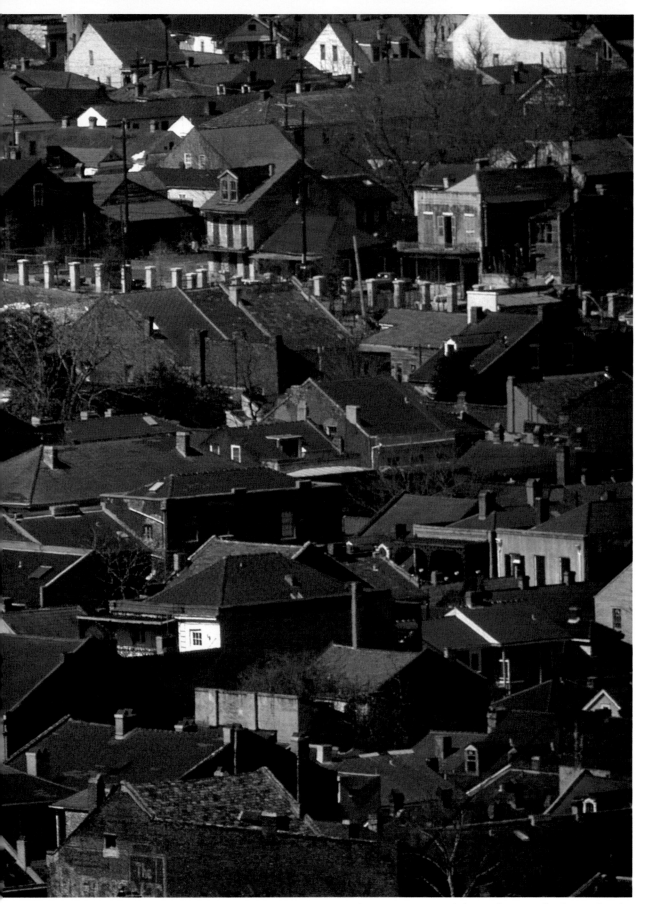

In the Vieux Carré, land was always scarce and the soil was soft. Accordingly, houses were small, close to each other and limited to four storeys. Nevertheless, the Creoles who inhabited the Vieux Carré created an amiable life style and left to later generations an architectural heritage unique in the United States.

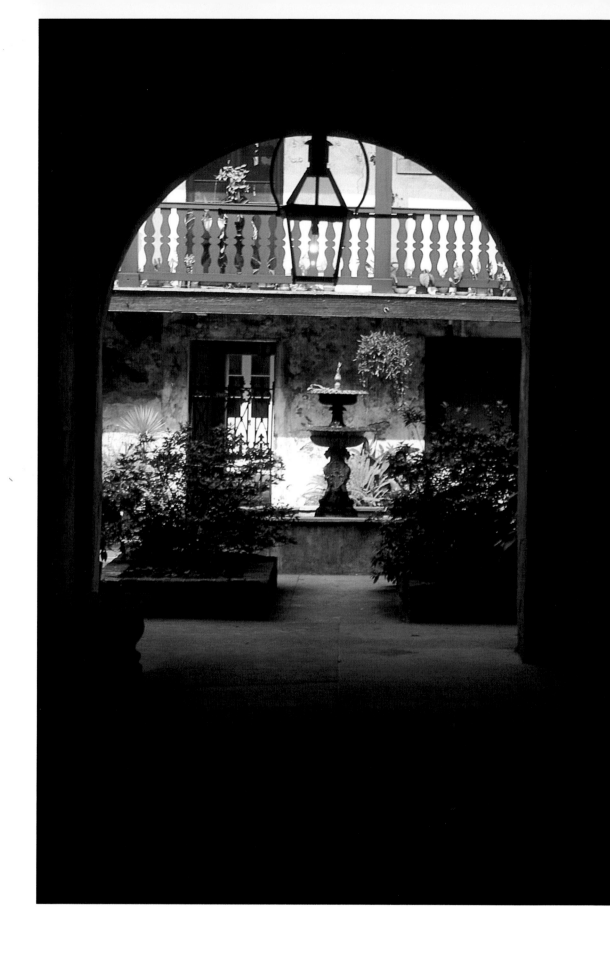

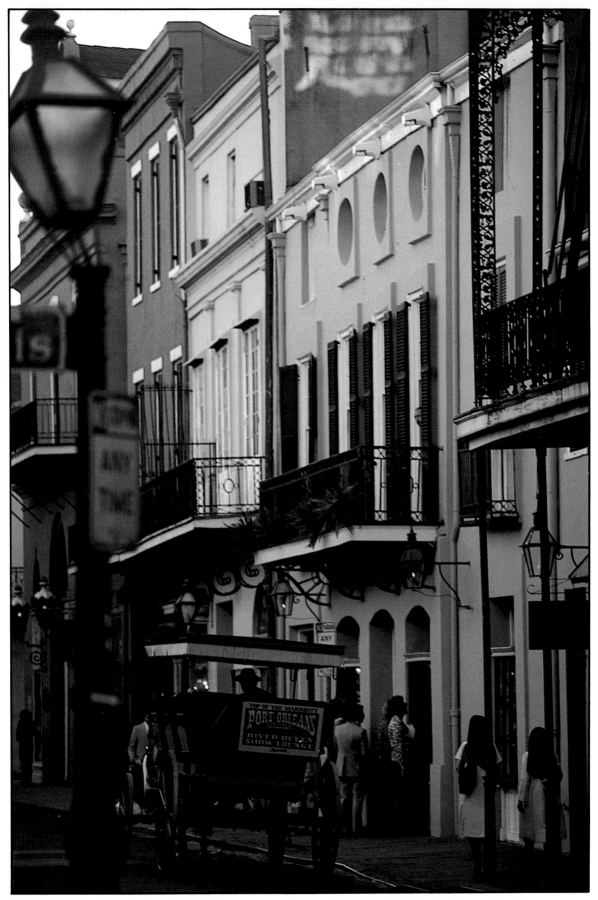

*Because of two devastating fires in 1788 and 1794, the Vieux Carré, as it exists
today, was built by the Spaniards and by the Americans who came after 1803.
The patio, with flowers and fountains, so much a part of
Andalusian life-style, is a Spanish heritage in the French Quarter.*

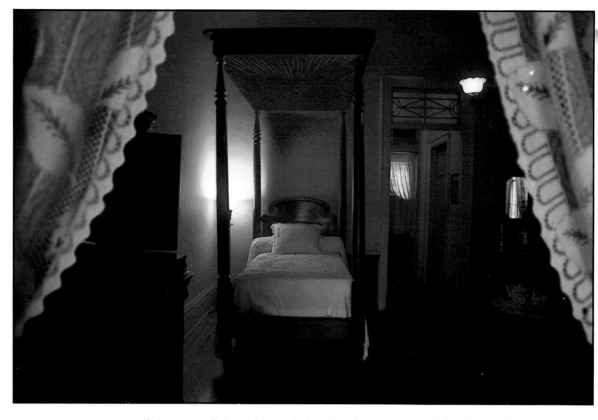

While most of the old Creole families have deserted the Vieux Carré, many of the fine old homes have been authentically restored to their original charming character. Such a one is the Hermann-Grima House, which the Christian Woman's Exchange has restored. It is opened to visitors, who can savor the taste of gracious 19th century living in New Orleans.

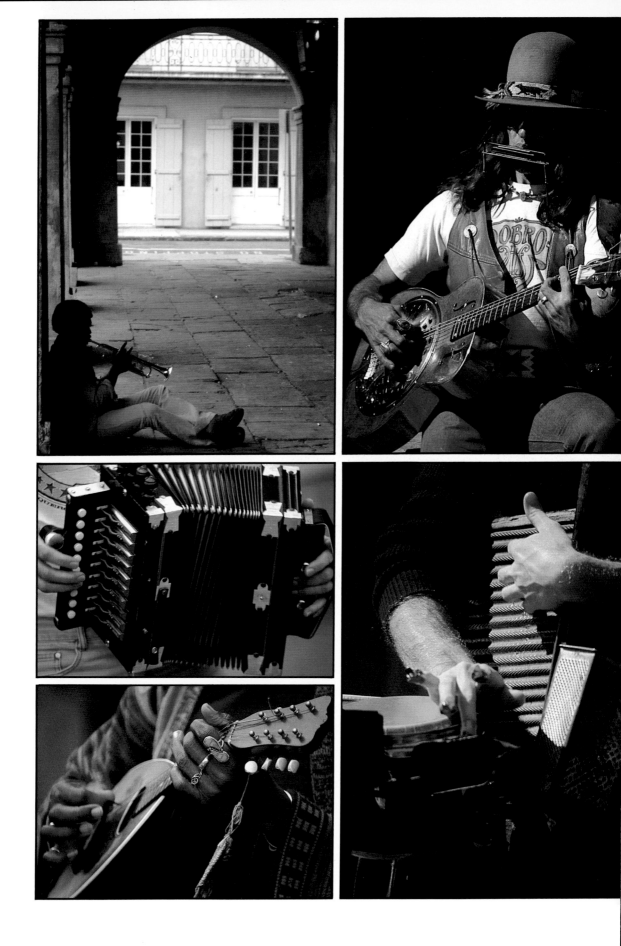

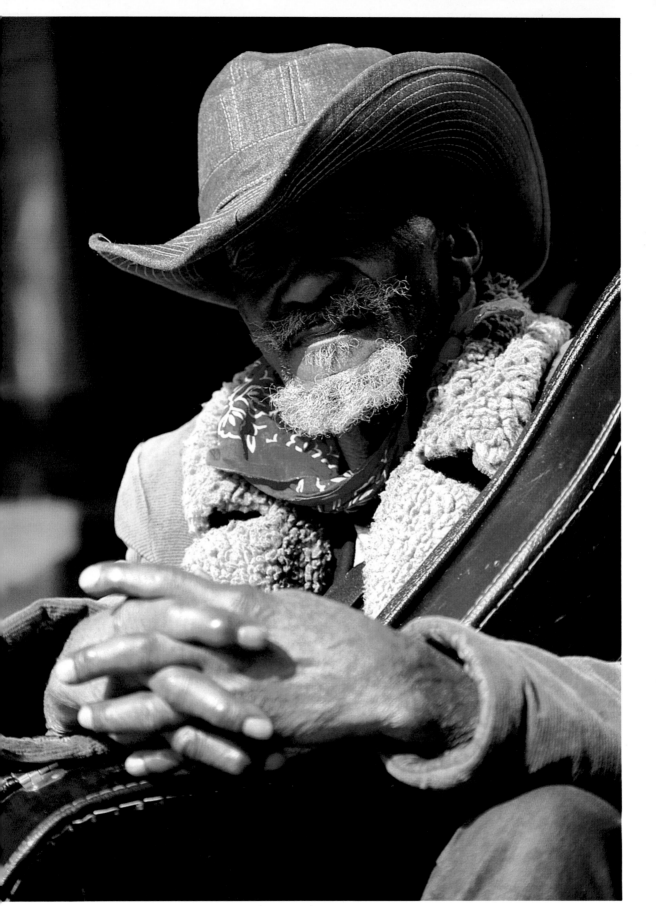

*Although New Orleans is known for its establishment of opera and the birth of
jazz, there is another musical tradition in the Vieux Carré—the street musicians.
Their instruments run the gamut from trumpets to steel guitars to Cajun
accordions to mandolins and even to the washboards of the "spasm" bands.
They may be heard on Bourbon and Royal Streets and around Jackson Square.*

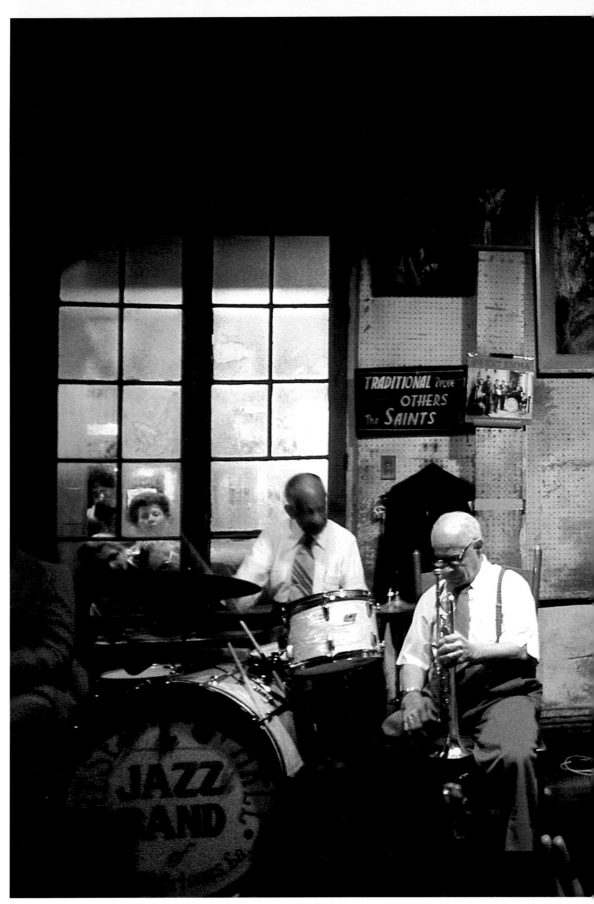

For the last two decades. Preservation Hall has been the Jazz Mecca for visitors from all over the world. Every evening a long line of "pilgrims" enters, dropping the traditional $1 fee into the basket. Once in Preservation Hall, they sit on the

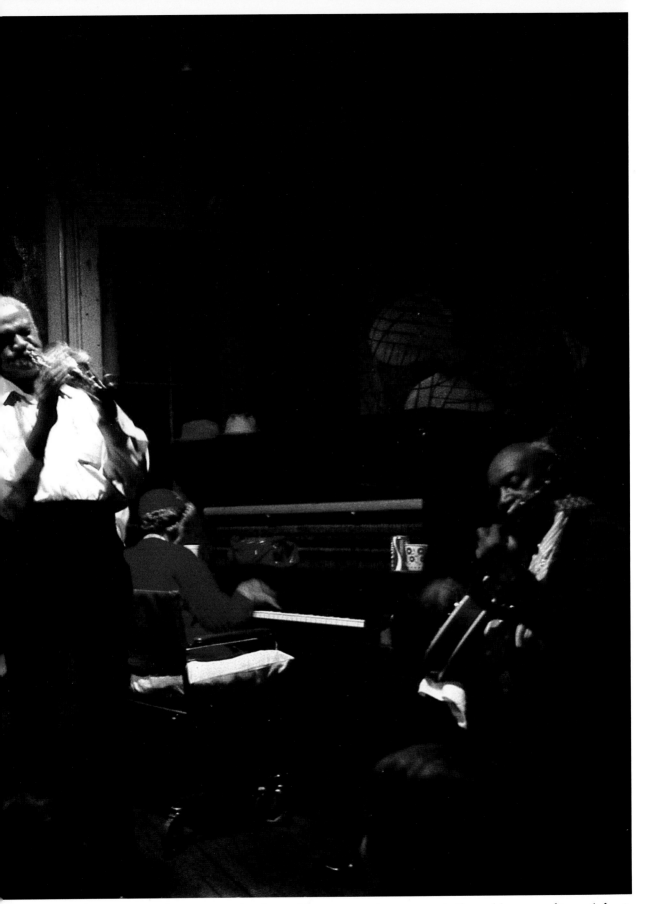

floor or stand to hear old time musicians recreate the golden age of jazz. A fee is expected for special requests as a sign above the band states, but if "When the Saints Go Marching In" is called for, an extra donation is required.

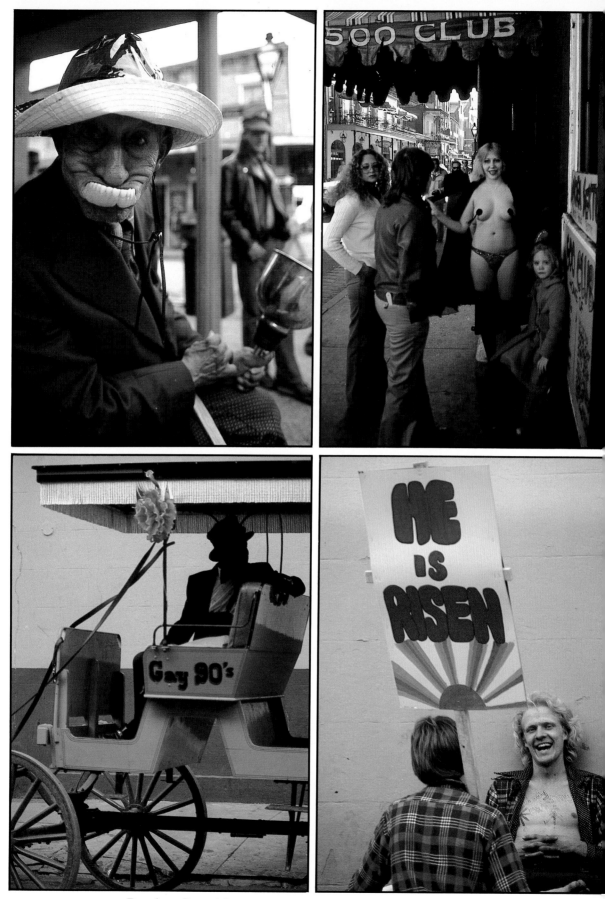

Bourbon Street! Some delight in it, some detest it, but no one can be indifferent to it, and its unique reality is found nowhere else. It is a nine-block long tawdry promenade which offers at every step unrestrained fun, raucous music, and food

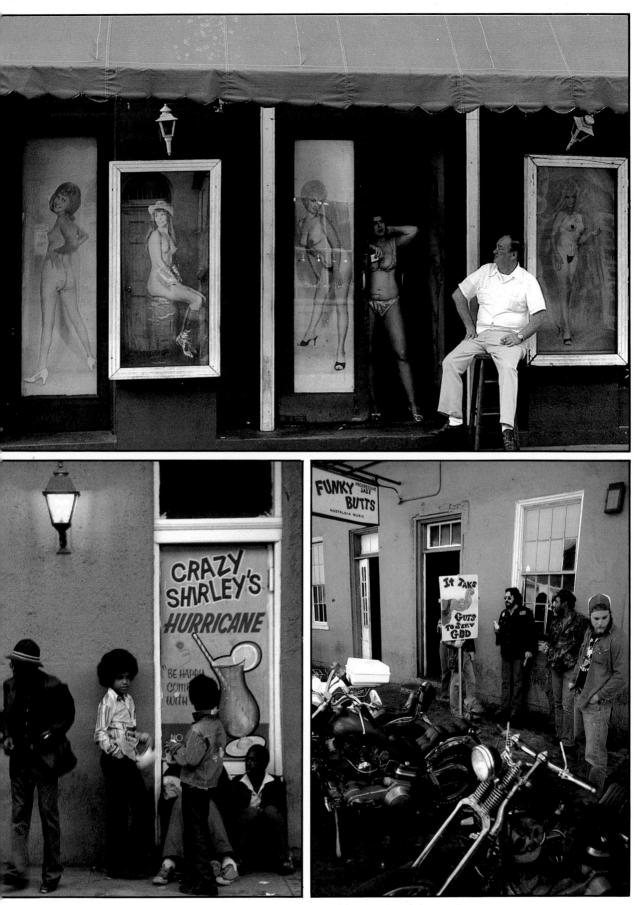

and drink. Bourbon street is a veritable "Lady of the Night," and as such awakens late in the day. Before the night action begins, tap dancers, strip teasers, joint barkers, shoeshine boys, carriage drivers relax, while street evangelists wage war on sin.

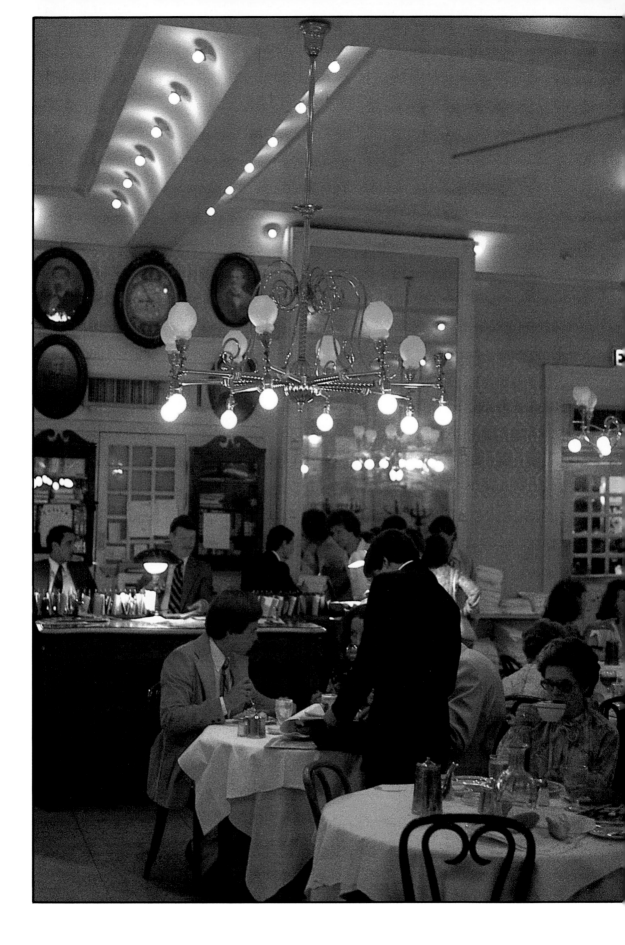

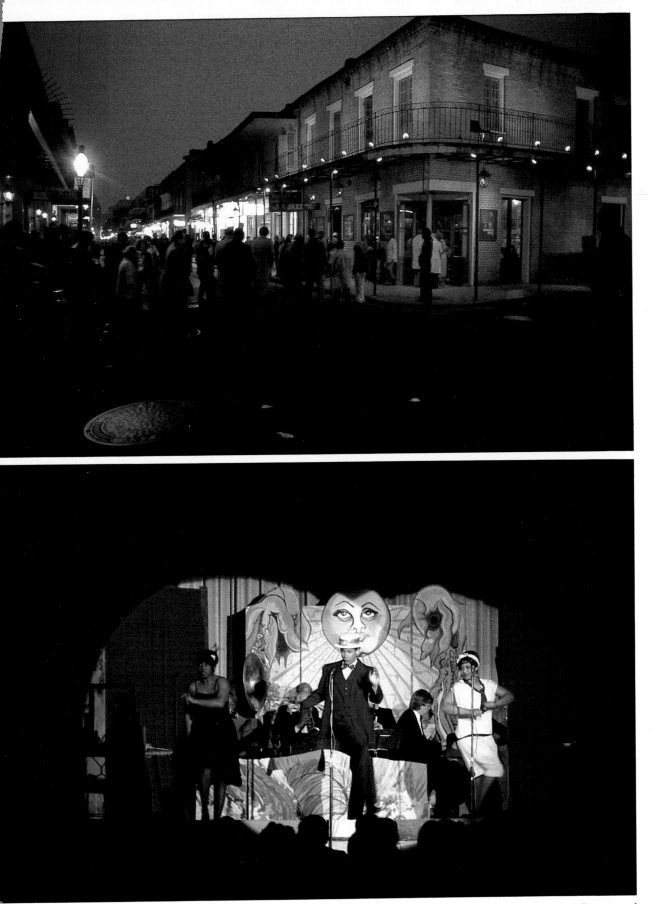

World-famous Antoine's Restaurant is one of the fixtures of the Vieux Carré and one may dine royally there in a decor that could have existed in 1840 when the restaurant was established. From Antoine's to the night world of Bourbon Street or the nostalgia of "One Mo' Time" at a French Quarter theater, is only a matter of a few steps and a few minutes.

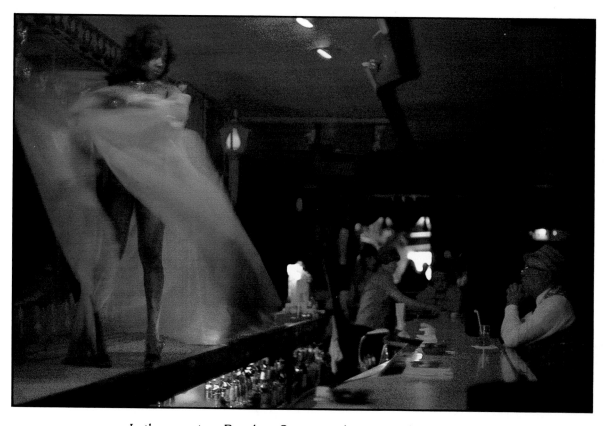

In the morning, Bourbon Street is asleep, its only activity being the daily clean-up of the previous night's litter and the restocking of food and drink. In the afternoon, the street is half awake, while "posing" passively for the cameras of browsing tourists. But in the night, Bourbon puts on its garish glitter and comes alive with a wide variety of night-characters. From midnight to dawn, the Bourbon Street show goes on in the lit-up corridor, filled with rowdy music and rowdy voices, while the rest of the Vieux Carré has long been asleep.

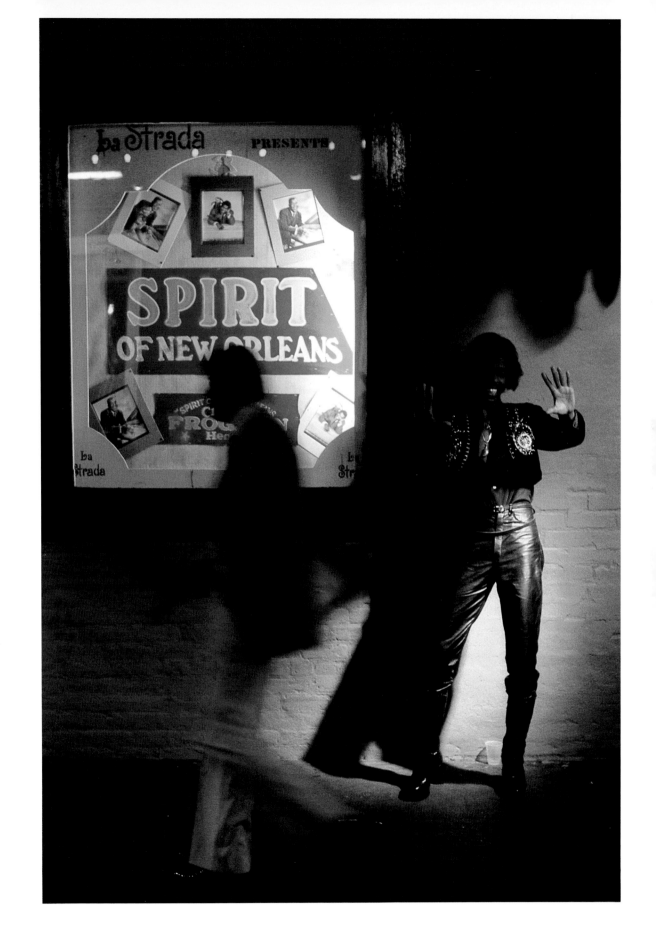

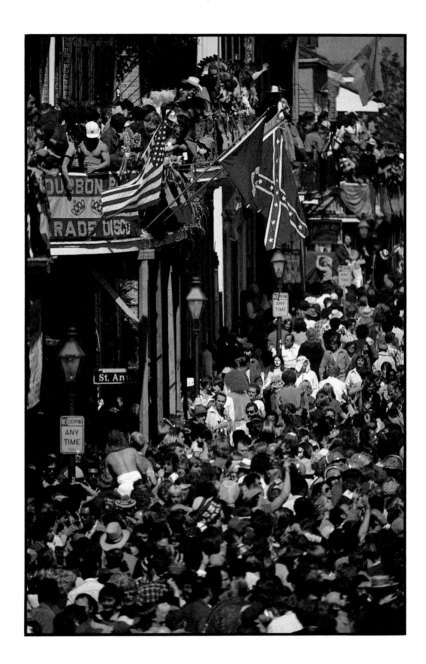

Masks and Merriment

New Orleans comes by its enthusiasm for Mardi Gras, naturally and honestly, for, as has been stated, "Mardi Gras" was the first name placed on the map of Louisiana by Pierre Le Moyne, Sieur d'Iberville, in 1699.

"Mardi Gras," or Fat Tuesday — the English call it Shrove Tuesday — is the culminating day of the pre-lenten Carnival, which medieval Europe celebrated with parades, feasts and fetes, and masked balls.

Mardi Gras is a "movable feast" because it is linked to Easter, which is itself a moveable feast based on the appearance of the full moon after the Spring Equinox. Give or take a few hours, the Spring Equinox falls on March 21. The first Sunday after the full moon that follows March 21 is Easter Sunday. Forty-six days back — 40 days of Lent plus six Sundays — is Ash Wednesday, the first day of the penitential season. The day before that is Fat Tuesday, Mardi Gras.

Traditionally, Mardi Gras was the last fling before the austerities of Lent. It was a consolation of the flesh before it submitted to lenten discipline; it was also a farewell to flesh meat, before rigorous fasting imposed by Church law and custom.

In medieval Europe, Carnival was essentially a Christian celebration with liturgical implications. It opened on Twelfth Night — January 6, the 12th day after Christmas — which is the Feast of the Epiphany, when the Magi brought their gifts to the Christ Child at Bethlehem. (Epiphany means "manifestation," and the feast recalls Christ's manifestation to the gentiles, or non-Jewish peoples, represented by the Magi).

It may well be assumed, although documentary evidence is lacking, that from the earliest days of New Orleans, Carnival was observed and that Mardi Gras had a special significance for the people. That balls and masquerades were held during the French and Spanish regimes is implicit in the fact that the first crisis in New Orleans under the American flag was a dispute between Creoles and Americans as to what music was to be played at a Carnival ball in 1804, just a few weeks after the transfer of Louisiana from France to the United States.

The first recorded Mardi Gras parade in New Orleans was in 1837. It consisted of maskers on foot, mounted on horseback and in carriages and it passed through crowded streets in the Vieux Carré. The parading maskers tossed candies and cakes, apples and oranges to the people who lined the parade route. This tossing of "throws" has been a Carnival parade tradition ever since the first parade. It is estimated that over $1 million worth of throws — beads, plastic trinkets, aluminum medallions,

called doubloons — are thrown annually to the Carnival crowds.

Rowdyism soon intruded into the annual Mardi Gras parade. It started harmlessly when maskers began to pelt spectators with little paper bags filled with flour. It was still harmless fun when the spectators began to bring bags of flour to the parade to return the "fire" of the marchers. But when pieces of brick were included in the bags, and quick-lime replaced flour, things began to get out of hand and the parades degenerated into near brawls between marchers and spectators.

Press and public, in 1849, clamored for an end of the "barbarous" observance of Mardi Gras. "Do away with it!" the newspapers chorused. "Genuine Mardi Gras… has passed away for ever," stated the *Bee*. The *Delta* complained that Mardi Gras "has become vulgar, tasteless and spiritless." The *Crescent* declared: "We hope we have seen the last of Mardi Gras."

It was quite evident, as the 1850s progressed, that Mardi Gras parades in New Orleans were heading for the discard. And then it was in 1857 that the Mistick Krewe of Comus made its appearance on Mardi Gras night and saved the celebration. It is interesting that New Orleans's world-famous Latin festival of Mardi Gras, as it exists today, was imported to the city by six Anglo-Saxons from Mobile.

The six expatriates from Mobile, which had Carnival celebrations before New Orleans, called a meeting of friends early in 1857 and organized a parade and ball for the approaching Mardi Gras. They chose the name of Comus, from John Milton's poem of that name. In Greek, the word *Konos* means a revel and the Mobilians were determined that revelry should rule on Mardi Gras. They created the pseudo-old English word, "krewe", from "crew" and then added "Mistick" to complete the organization's name — the Mistick Krewe of Comus. The Comus organization created the form and pattern of Carnival parades that still exist to this day and their word "krewe" has now become a generic term to describe the membership of any Carnival organization.

When the Civil War came in 1861, Comus suspended its activities for the duration, thereby setting another Carnival pattern. Every war or national emergency has seen the suspension of Carnival affairs.

In 1870, the Twelfth Night Revelers came into being and for half a dozen years the group staged both a parade and a ball. The Twelfth Night Revelers still exist today, but this krewe has not paraded for more than a century.

When it became known in 1872, that the Russian Grand Duke Alexis would visit New Orleans during Carnival, some young business-

men of the city decided to organize a day parade for Mardi Gras in the Grand Duke's honor. They chose a king and called him Rex, King of Carnival. Ever since, the honor of being chosen Rex is conferred on an Orleanian whose leadership in civic, cultural or charitable affairs is universally recognized. New Orleans offers no higher honor.

In the same calendar year of 1872, but on New Year's Eve — so actually in the Carnival season of 1873 — there rode forth for the first time the Knights of Momus. And in 1882, the Krewe of Proteus entered Carnival with a parade and ball, thus completing the so-called "Big Four" parading krewes of the 19th century. This same year of 1882 marked the establishment of a tradition which is the culminating highlight of Carnival — the meeting of the courts of Rex and Comus at the Comus ball, shortly before midnight.

By the beginning of the 20th century, there were only a handful of Carnival krewes active in New Orleans. Some groups made brief appearances in Carnival and disappeared. Some tried parading and gave it up, leaving Comus, Rex, Momus and Proteus in the field. In 1909, Zulu, a black krewe, which once had Louis "Satchmo" Armstrong as its king, appeared for the first time and Zulu is still going strong. After World War I, there was a Carnival boom, and along with many new krewes, women's parading groups began to appear. But the real "explosion" came after World War II. Today, New Orleans and its suburbs have more than 50 parades and during Carnival more than 60 balls are staged at Municipal Auditorium alone.

How is this massive funfest — Orleanians call Carnival "the greatest free show on earth" — financed? How is it subsidized? Carnival is completely unsubsidized; it is totally financed by the dues-paying members of each krewe.

How do the krewes coordinate the numerous parades and balls? They don't. Each krewe is a law unto itself, completely individual, making its own rules, picking its own members and staging its own activities, be they parade or a ball, or both, completely independent of any other krewe.

The only coordination in Carnival is the allocation of dates for balls at Municipal Auditorium, which is divided into two separate ball-rooms, so that two balls may be held at the same time. Year after year, long-established krewes are assigned approximately the same dates. Problems arise when the Carnival season is a brief one. This results when there is an early Mardi Gras, which can fall as early as February 3, as it did in 1818, but which it won't do again until the 22nd century. March 9 is the

latest on which Mardi Gras can fall, which it did in 1943, and will do again in 2083.

The captain is the do-all and be-all of a krewe. He may be elected by the membership or he may be named by the krewe's "hierarchy." His tenure may be limited or it may last as long as the captain wants to handle this important job. Remember, each krewe makes its own rules. The captain makes all the decisions for the krewe and is responsible for staging a parade or a ball, or both. He chooses the theme of the presentation, arranges for costumes, masks, floats, "throws," krewe favors, rental of the hall and a hundred other details. The captain, more often than not, delegates to lieutenants different phases of the preparation of the annual event. To be king of a krewe is an honor; to be captain is a year-round volunteer job, in addition to one's normal duties.

The older Carnival organizations draw on the season's debutantes for their queens and maids of the court. And among the older krewes other than Rex, the identity of the king is never made public, although it is a secret kept not-too-well once the ball gets underway.

Carnival in New Orleans is even more than the "greatest free show on earth." It represents, in all its aspects, a $15 million part of the New Orleans economy. This is New Orleans money, spent in New Orleans by the krewes and their members and circulated in New Orleans as each Carnival unfolds. Tourist dollars pour into the city, too, but Carnival in New Orleans never was, and probably never will be, "tourist bait." If not a single tourist visited New Orleans during Carnival, the festival would still go on and still generate the conservatively-estimated $15 million flow into the city's economy.

Another aspect of Carnival might very well be overlooked in the fun and excitement of the event. Psychiatrists have said that Carnival, the greatest possible annual "steam-let-offer" in America, is good for the mental health of the community. The most potent "psychiatric treatment" comes, of course, on Mardi Gras, the culmination of Carnival.

Years ago, Carnival opened on Twelfth Night, with the ball of the Twelfth Night Revelers, but the proliferation of krewes has advanced the opening of the ball season to around Christmas. The Carnival parade season opens 12 days before Mardi Gras and from two to seven parades are held each day or night leading up to Mardi Gras. Everything in Carnival that has taken place must take a back seat to Mardi Gras, when street masking from sunrise to sunset is permitted by law.

What a day is Mardi Gras! Hundreds of thousands on the streets, lining the parade route of Rex, King of Carnival, with a half a million

people concentrated on Canal Street. Parades are almost continuous from 10 a.m., when Rex begins to roll, until the last float of the night parade of the Mistick Krewe of Comus pulls up to Municipal Auditorium about 8 p.m. Following the Rex parade come the two so-called "truck parades" — the Krewe of Orleanians, and the Krewe of Crescent City. The Elks created the former in 1935, and for a few years the flat-bed trucks were simply decorated. Today most of the floats in the two "truck parades" are elaborate affairs and between them they total more than 200 vehicles, carrying about 7,000 maskers. In the meantime, another colorful parade, that of Zulu, a black krewe more than 70 years old, has wended its way in another part of the city through cheering throngs. In the milling crowd there are at least 75,000 in costume and mask and the most impressive of these are the Mardi Gras Indians, "tribes" of black members, whose feathered costumes and head dresses are the most elaborate and the most costly of Carnival regalia. Mardi Gras marching clubs are another feature of Carnival. The oldest of these groups is the Jefferson City Buzzards, who began Mardi Gras activities in 1890.

The theme of Mardi Gras is a tune called "If Ever I Cease to Love," which Rex lifted from a musical comedy of 1872 entitled "Bluebeard" to become his "national anthem." Whenever the King of Carnival is toasted on his parade route, and for his entrance and departure from the Rex ball, the band plays "If Ever I Cease to Love." And when Rex calls to pay his compliments to Comus, oldest of the Carnival monarchs, it is played again. This ceremony is the highlight of Mardi Gras.

The Rex and Comus balls are both underway at the same time in adjacent halls of Municipal Auditorium. The two monarchs rule only a couple of hundred yards from each other, their Carnival "palaces" separated by only a fire curtain and several layers of draperies which prevent the music of either ball intruding on the other. During the Rex ball, the costumed, masked and plumed captain of Comus calls on Rex and invites the Carnival King and his court to visit the Mistick Krewe of Comus and its king, queen and court. At 11:20 p.m., distant trumpets are heard, announcing the approach of the King of Carnival. Twice more the trumpets sound, a little nearer each time. At the last note, Rex and his Consort appear, the orchestra strikes up "If Ever I Cease to Love," and the royal welcome by Comus ensues. Then follows the Grand March, with Comus escorting the Queen of Carnival and Rex escorting the Queen of Comus. When the four monarchs are seated on their thrones, maids of both courts salute them and the ball resumes. At midnight, "the Captains and the Kings depart." Carnival has ended.

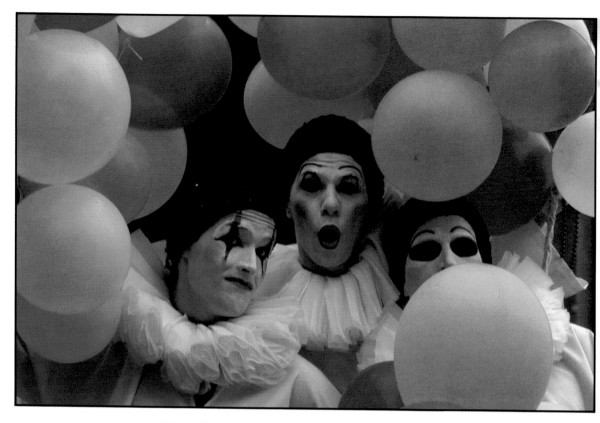

Mardi Gras in New Orleans is fun at a furious pace. It is make-believe and merriment, masquerade and mockery, milling and marching revelers...

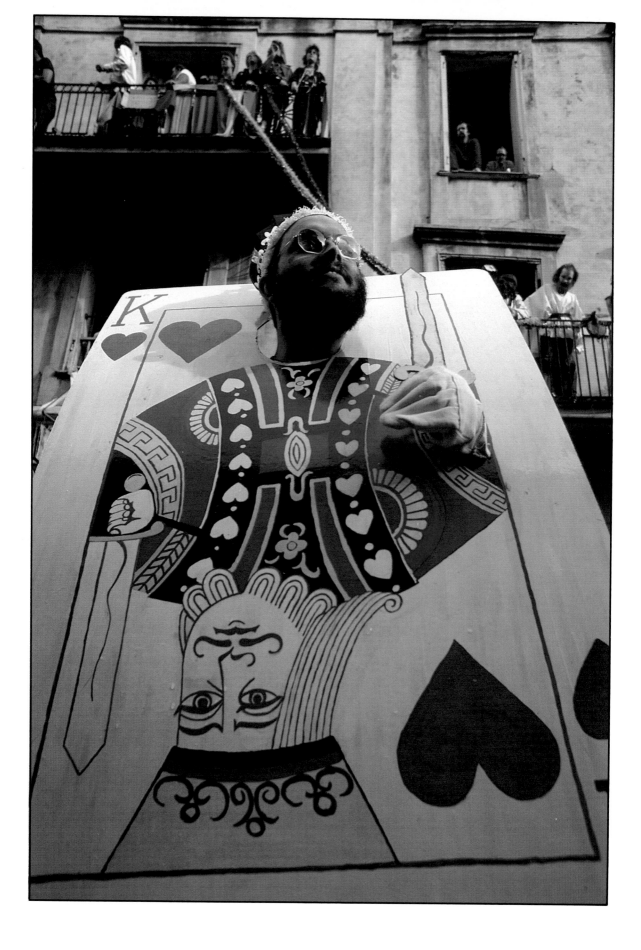

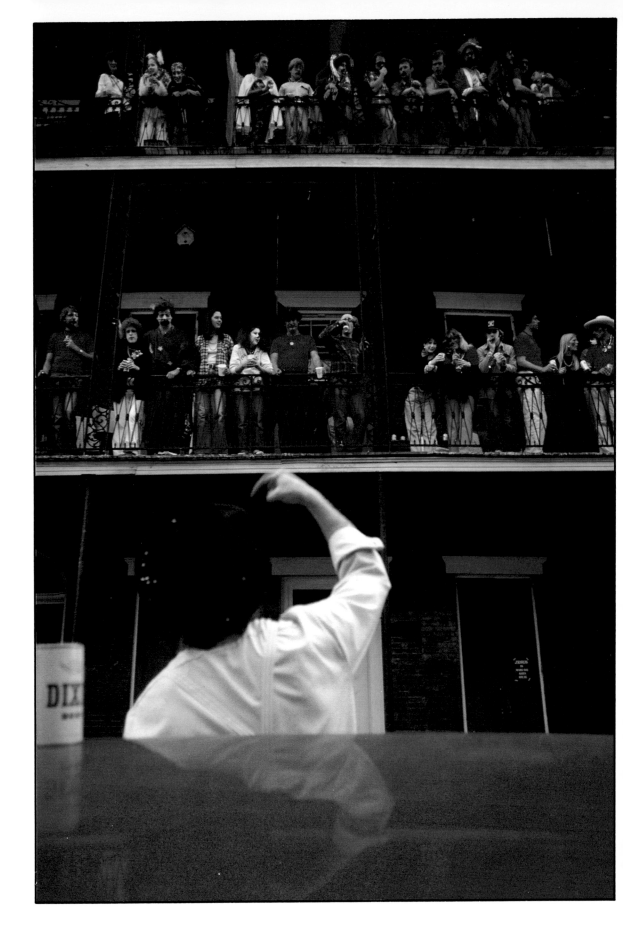

French Quarter balconies lined with people in costume, enjoying the fun of which they themselves are a part, contrast with the dense throngs that fill the streets below. The spirit of camaraderie prevails as the passing crowd and those on balconies engage in spirited dialogue...

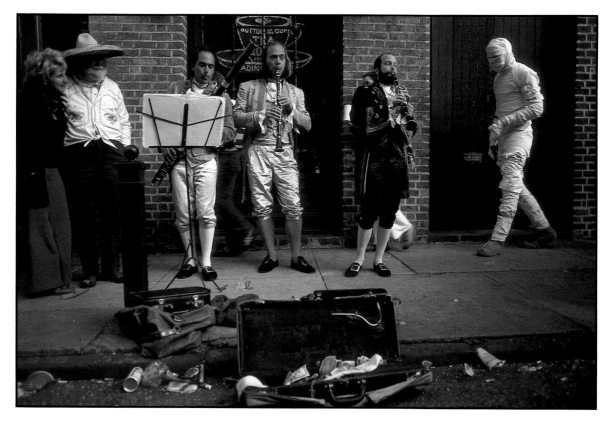

Mardi Gras, like the street fairs of the Middle Ages, attracts street musicians, jugglers, fire-eaters, acrobats, sword-swallowers who perform in the crowded Vieux Carré for a contribution.
There are even street artists who'll paint one's face grotesquely for a fee.

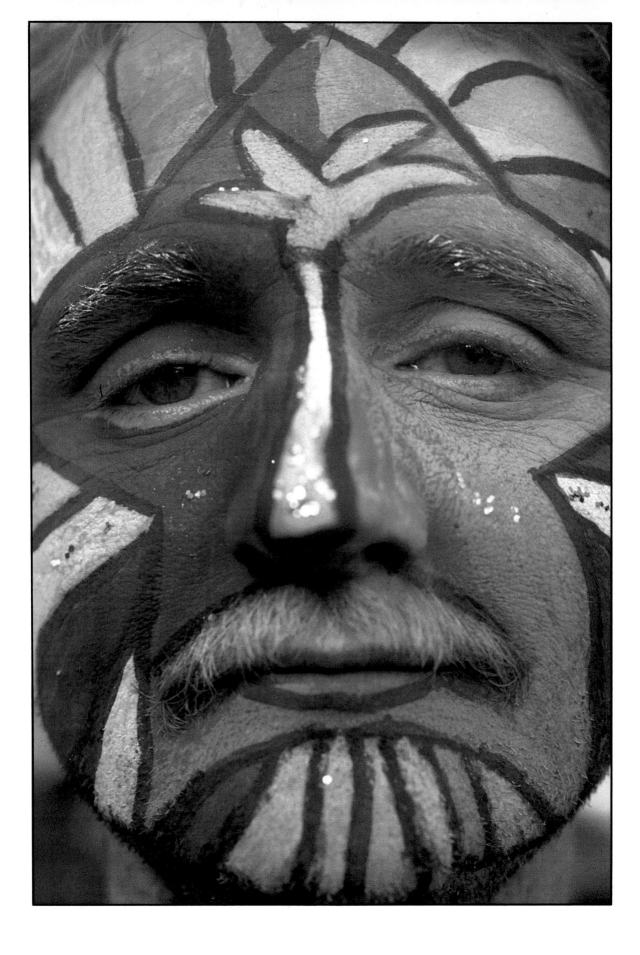

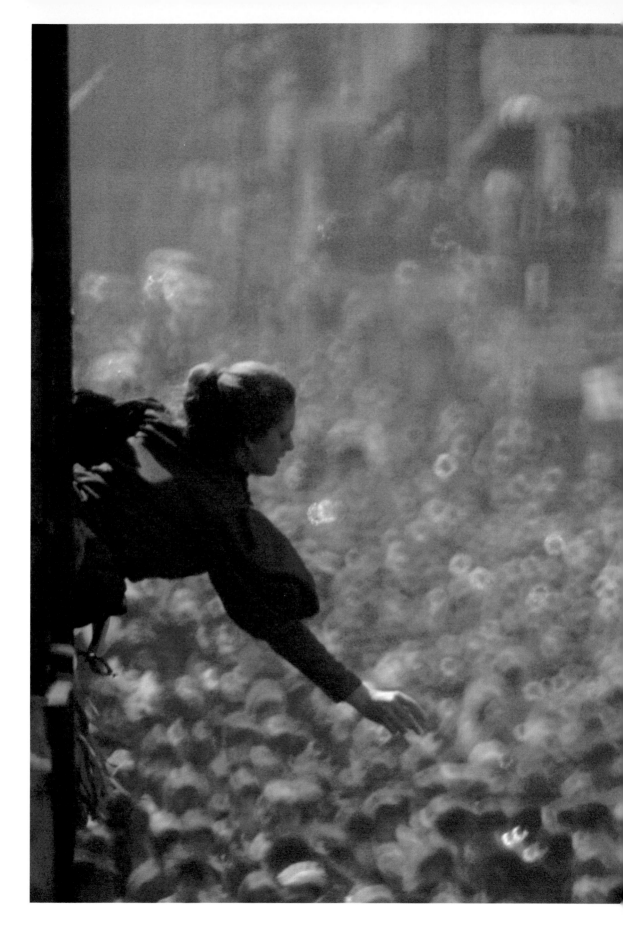

Although the swaying floats of Carnival parades no longer roll through the French Quarter, where narrow streets multiply the hazards of disastrous fires, the Mardi Gras crowd is undiminished on Bourbon and Royal Streets. It actually becames a matter of "wall-to-wall" people, who exhibit an amiable tolerance while being pushed, jostled and stepped on.

139

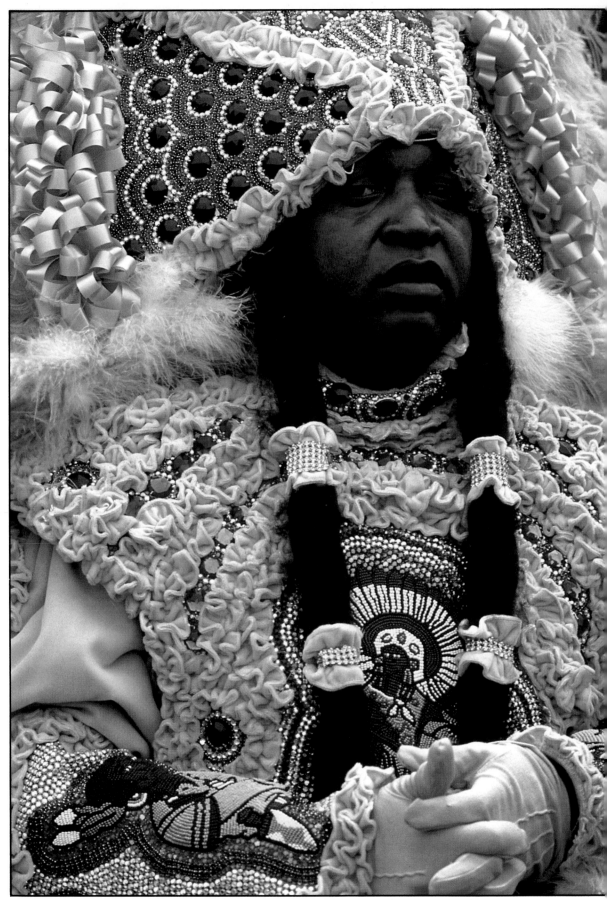

"The Indians are coming!" shouts Chief Jake. The response, like a war cry, roars out: "Two way, Packaway, the big chief's coming!" Mardi Gras Indians are century-old black "tribes" bearing such colorful names as "Wild Magnolias," "Wild Squatoolas," "White Eagles," and "Yellow Pocahontas." On Mardi Gras

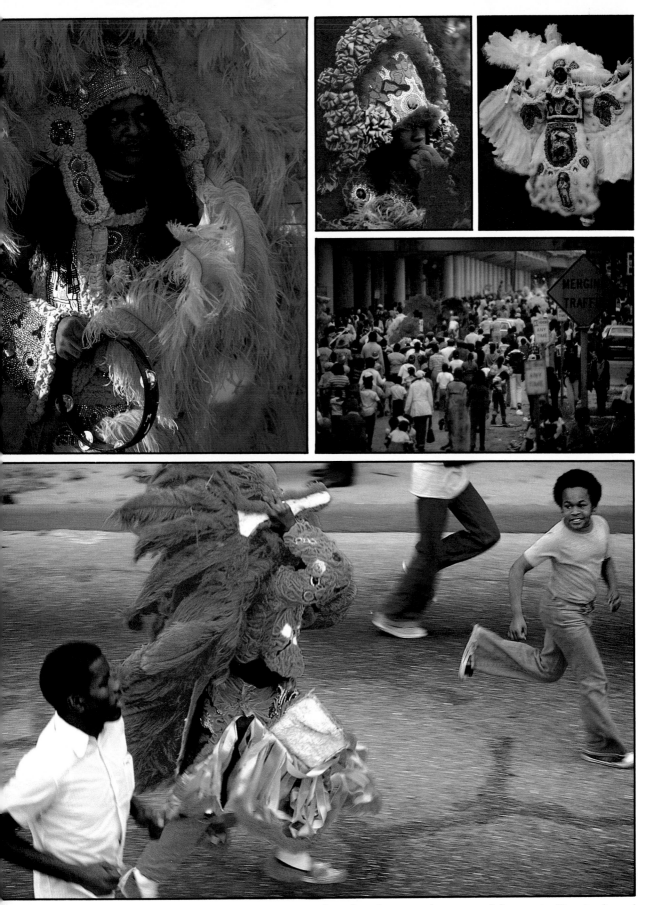

and St. Joseph's Day, tribes don their regalia, most elaborate in Carnival, and march in a loose second line in ritual singing and dancing. "Flag boys" and "Spy Boys" scout ahead as when bitter rivalry between uptown and downtown tribes often led to bloodshed and death. Today's Indians are peaceful, but their ritual parades continue.

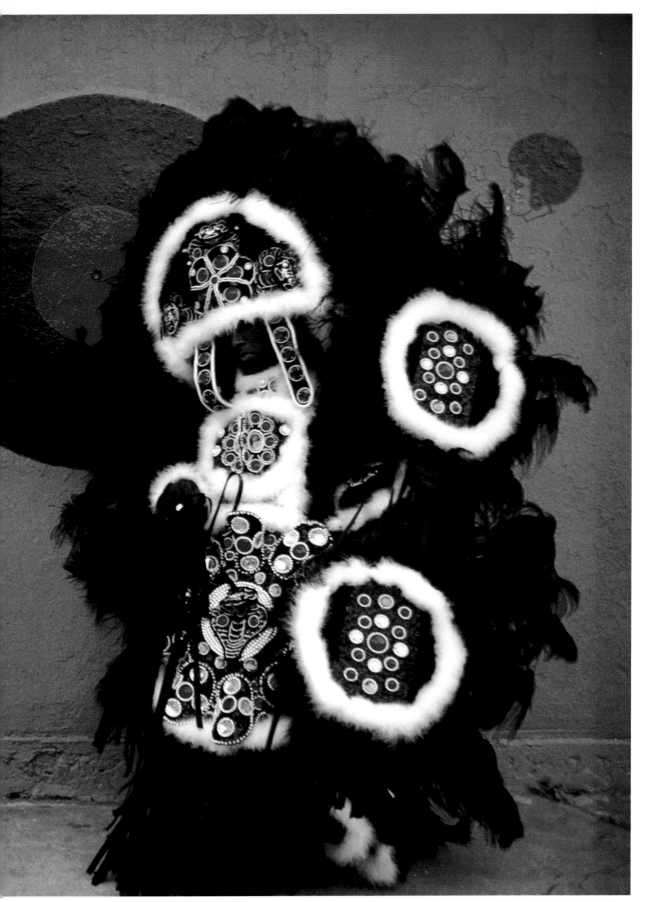

After St. Joseph's Day, the magnificently feathered costumes of the Mardi Gras Indians are re-done in accordance with each tribe's secret color scheme for the coming year. Much time and money are spent by the Indians in the "off" season remaking their costumes in their own homes. Rehearsals of songs and dances for the coming celebration become frequent in the months before Mardi Gras.

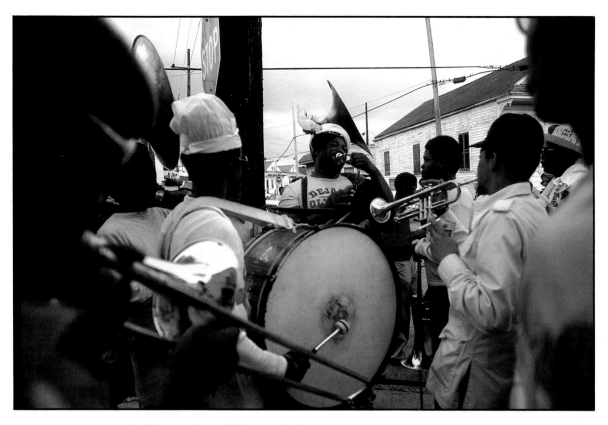

In the parades of the Mardi Gras Indians, as in any black parade in the city, the second line is the fidgitty crowd, strutting and dancing around the brass band. Here are shown the "Money Wasters Social and Pleasure Club" (right) and the "Sixth Ward Dirty Dozen Brass Band" (left). The spontaneous second line has become a year-around tradition, exemplified in Jazz funerals, club parades, and other black community functions.

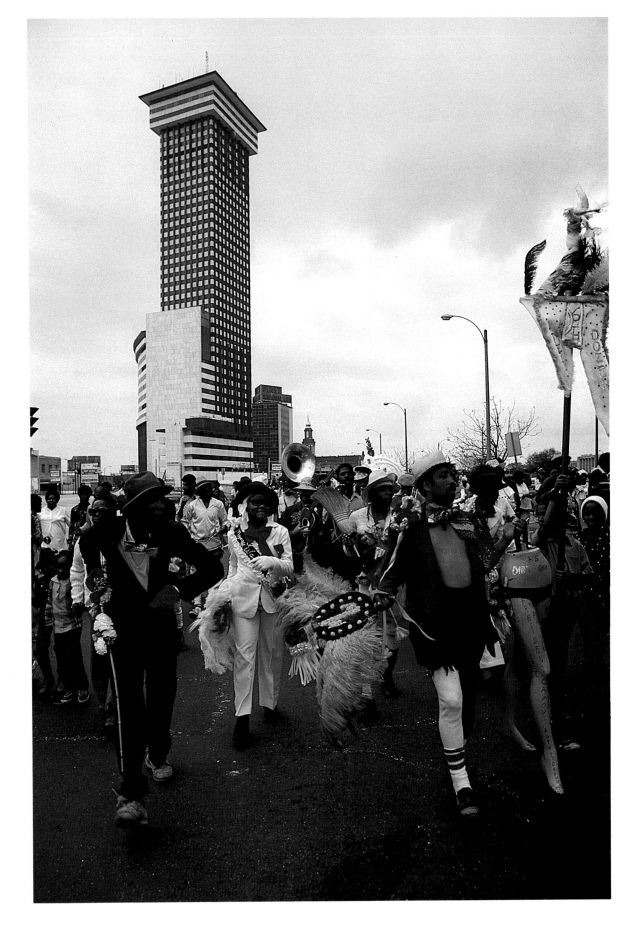

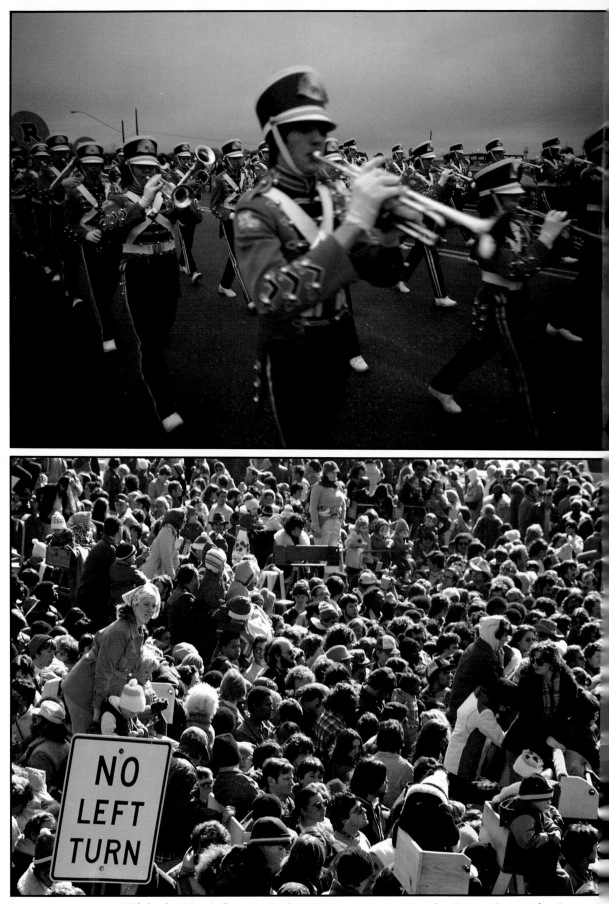

While the Mardi Gras "sideshow" is concentrated in the Vieux Carré, the "main show" takes place in many parts of New Orleans with the parades which reach their climax on Canal Street. From the traditional four parades of the 19th century—Comus (1857), Rex (1872), Momus (1872), and Proteus

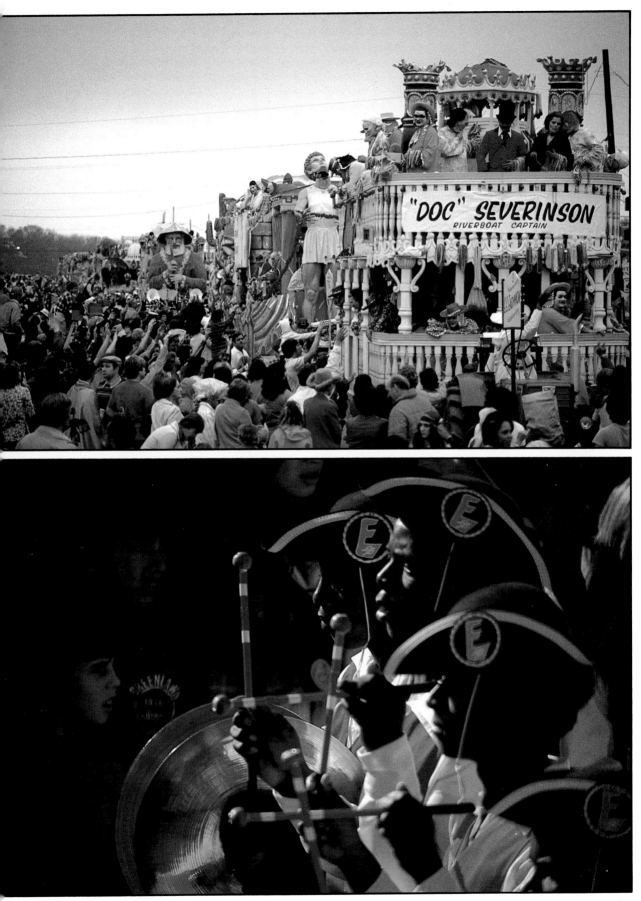

(1882) — Carnival has spread to the suburbs and today New Orleans and its environs stage more than 50 pageants during the season. A typical parade consists of floats with maskers, marching units and school and college bands, and mounted "dukes" who kept the parade rolling.

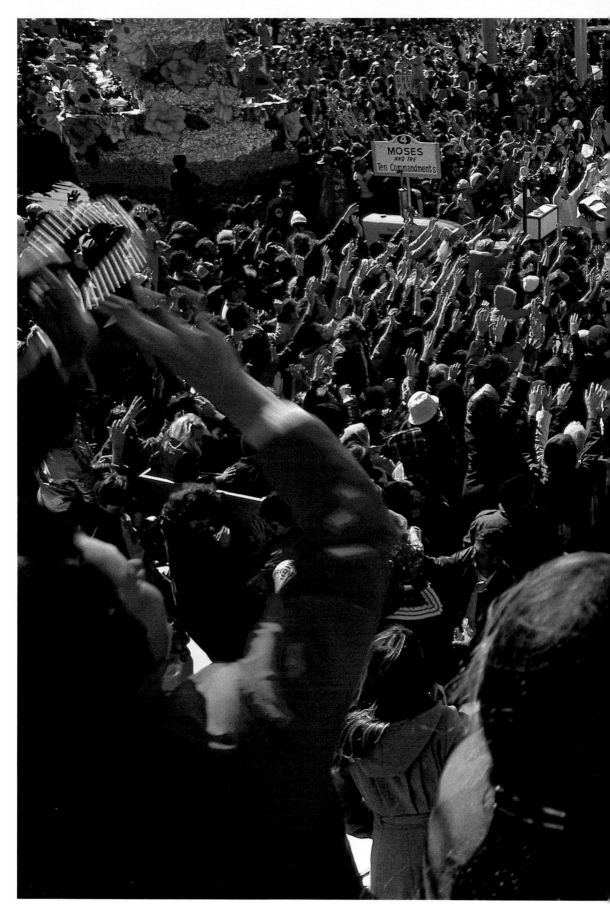

"Hey, Mister, throw me something!" This is the theme-song of Carnival, as thousands of parade-goers, drawn from all ages and walks of life, scream for beads, trinkets and "doubloons," which the maskers toss from the floats. It is estimated that more than $1 million of trifles is thrown to the Carnival crowds

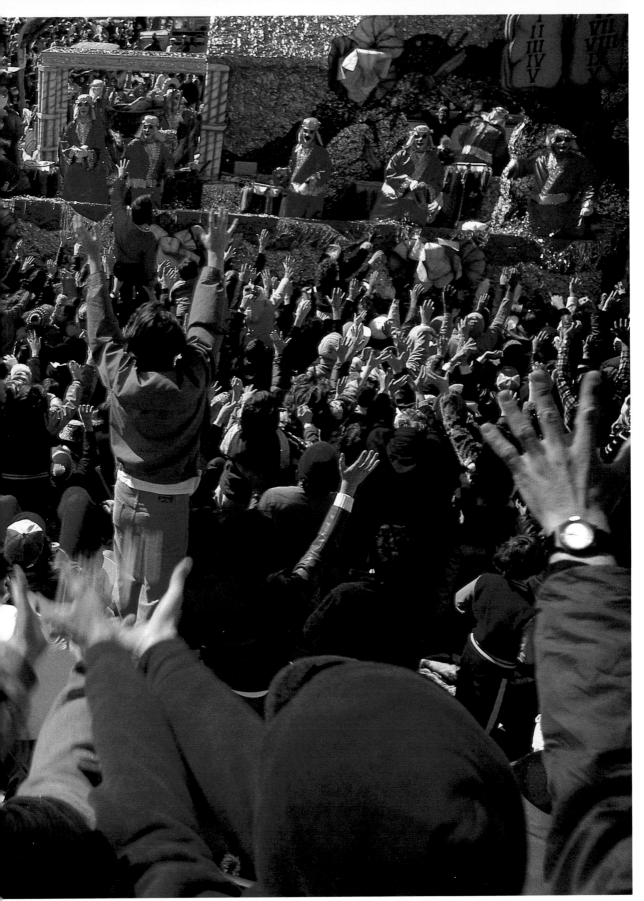

annually. The "doubloon," an aluminum medallion introduced by Rex in 1960, won immediate popularity, and all parading krewes now toss them. Doubloons are eagerly sought and readily scrambled for, because they have spawned a new collectors' mania.

Behind the outward show of floats, maskers and marchers is the solid fact that Carnival represents a $15 million share of New Orleans' economy. It is staged by the dues-paying members of each organization, all of which operate under their

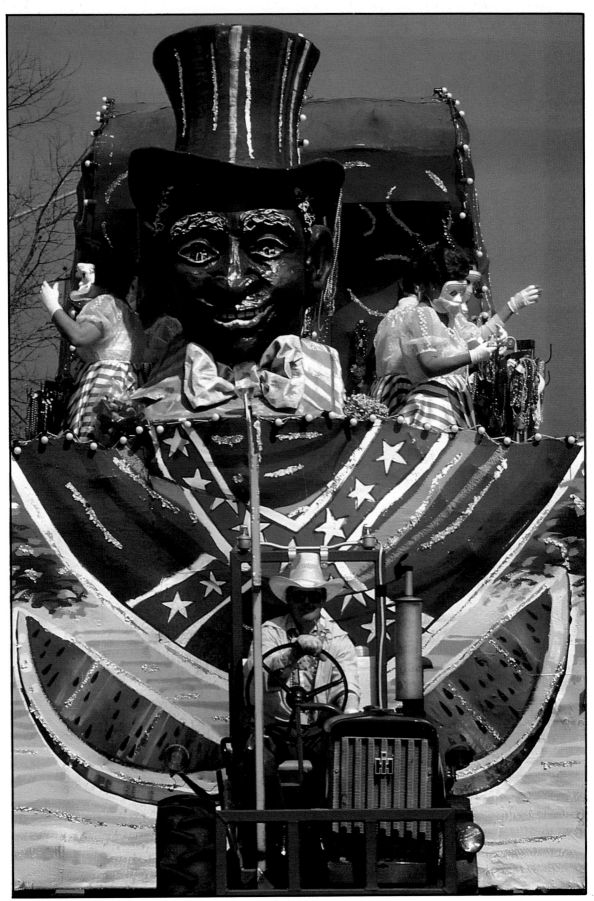

own regulations, without coordination with other Carnival groups. The Carnival "explosion" is not confined to the parades. From an original handful of balls, the Carnival calendar contains more than 60 such events at Municipal Auditorium alone.

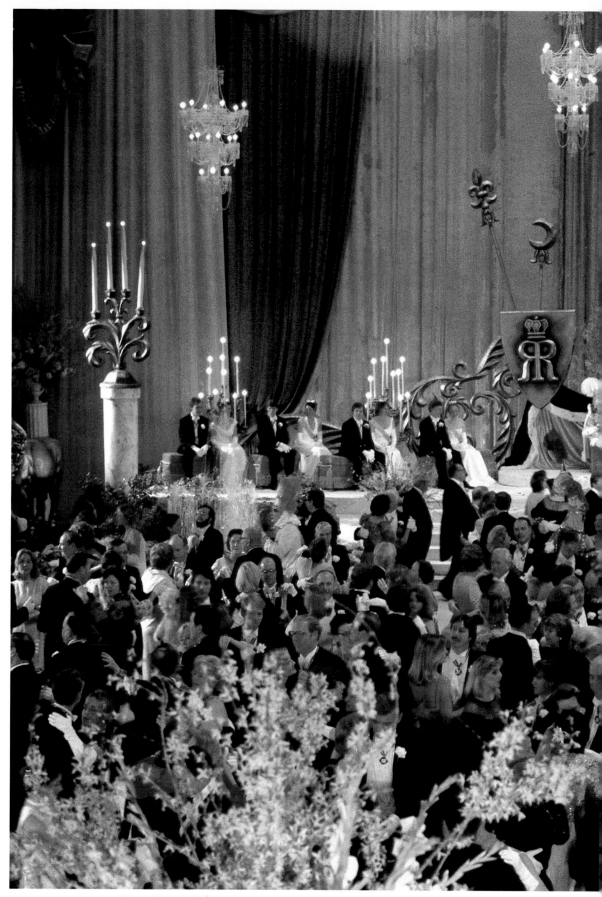

Rex, King of Carnival, with his Queen, rules over a ball on Mardi Gras night on one side of Municipal Auditorium, while on the other side, the Mistick Krewe of Comus holds its colorful fete. The honor of being King of Carnival is bestowed

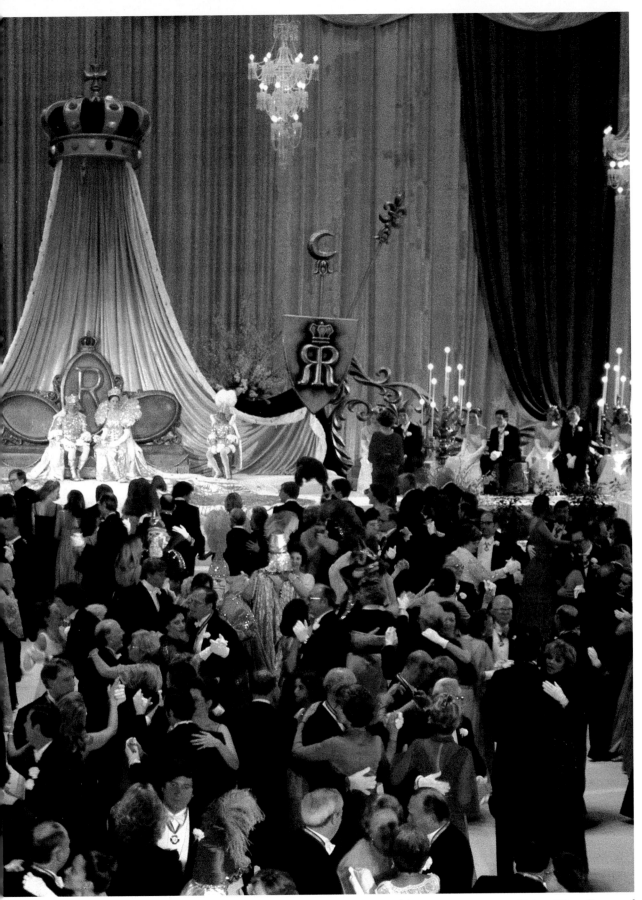

on an Orleanian who has rendered notable services in civic affairs. The climax of
Carnival comes at 11:20 p.m., when Rex, his Queen, and their court leave their
ball to visit Comus to pay respects to the oldest of Carnival kings.

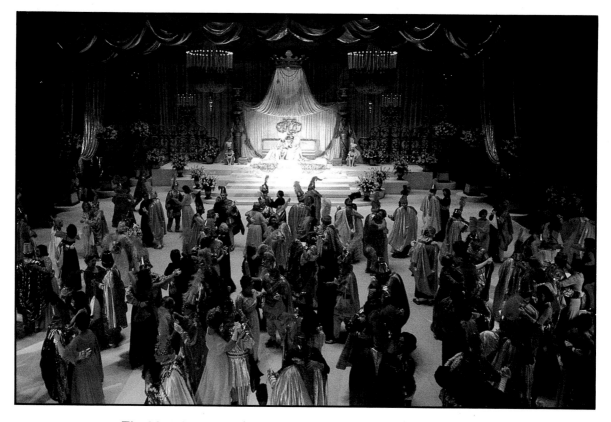

The Mistick Krewe of Comus ball is a bal masqué of Old World tradition. Comus and his costumed krewe wear masks and the king's identity is never made public. There is an old saying that if the Comus ballroom collapsed, it would wipe out the first families of New Orleans. The climax of Carnival is the meeting of two courts, when Comus welcomes Rex as he enters the ball floor. A grand march follows with Comus escorting the Queen of Carnival and Rex escorting the Queen of Comus. Then the four Carnival monarchs ascend the throne, from which they receive the homage of the maids of the courts and their escorts. Then the orchestra strikes up the dance again and the ball goes on. At midnight, "the captains and the kings depart" and the Mardi Gras merriment comes to an end as Ash Wednesday, the first day of Lent, arrives.

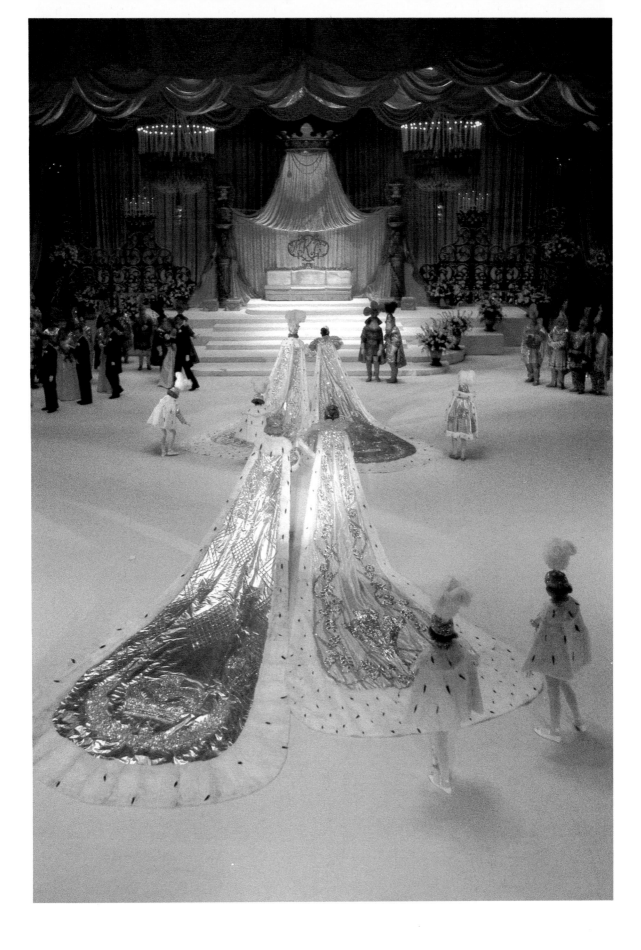

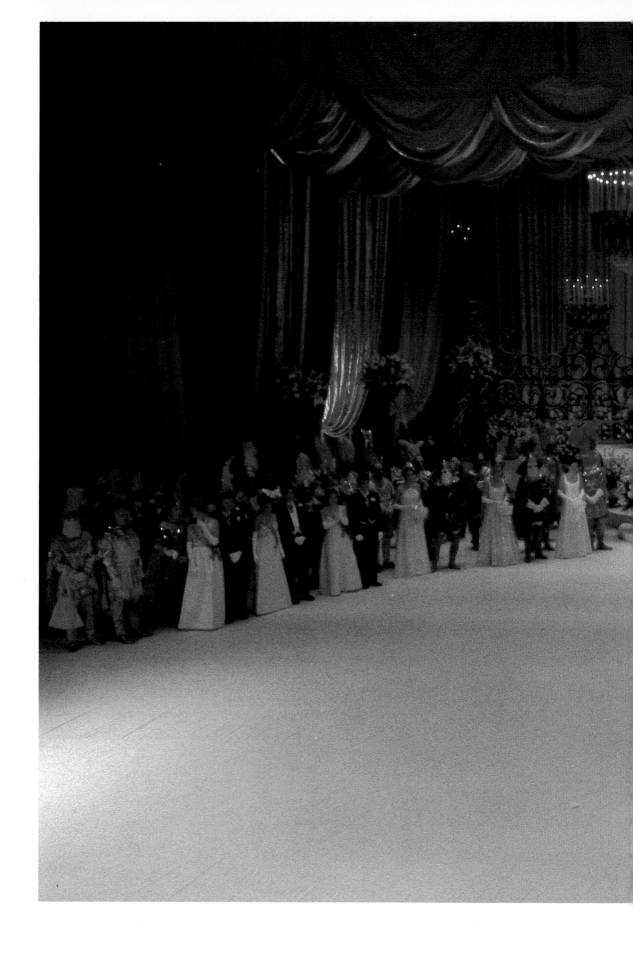

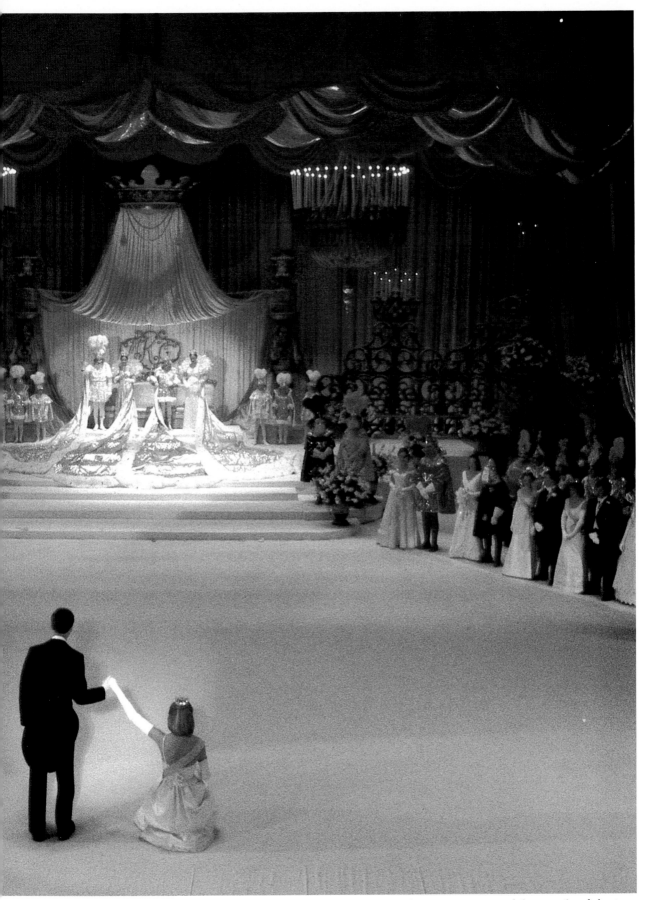

*Traditional to the Comus-Rex finale is the presentation of the maids of the two
courts to the Carnival monarchs. A unique embellishment to this tradition
occurred in 1950 when the Duke and Duchess of Windsor bowed and curtsied to
the four Carnival rulers, graciously accepting the tongue-in-cheek situation of
the one-time King of England paying homage to mock royalty.*

157

Enigma and Paradox

New Orleans is a living example of the French expression: "The more things change, the more they are the same."

Changes — often resisted, but inevitable changes, nonetheless — have taken place in New Orleans, but because the city is a "state of mind" as well as a place of timber and brick, New Orleans continues in many ways to be as it was a century or two ago.

Take the matter of gambling, which authorities started trying to suppress in 1723 with this decree: "It is forbidden to play, at home, any game of chance... or with stakes... It permits only games of recreation." Today, the police continue their futile efforts to stamp out gambling.

The young Ursuline novice, Sister Marie Madeleine, found in 1727 in New Orleans "much of magnificence" and that "cloth of gold and velours are commonplace." Nearly three-quarters of a century later, Pierre Clement Laussat, sent to Louisiana to prepare for the French occupation which was cancelled by the Louisiana Purchase, noted that in New Orleans "the luxury of the wardrobe resembles that of Paris." In New Orleans today, it is said, more evening clothes are sold than anywhere else in the United States, due to Carnival.

The propensity for dancing, so evident during Carnival when annually more than 60 balls are held at the Municipal Auditorium alone, is an old New Orleans custom. A French officer wrote in 1744: "The rich spend their time in seeing their slaves work to improve their lands and get money, which they spend in Gambling, Balls and Feasts." Two French visitors about the time of the Louisiana Purchase noted the Creole passion for dancing. Baudry des Lozières characterized New Orleans as "the place where they dance the most," while Berquin-Duvallon noted: "They dance in the city, they dance in the country, they dance everywhere." The first American governor of Louisiana, William C.C. Claiborne, described Orleanians as "uninformed, indolent and luxurious."

Changes come, as come they must, but New Orleans, as few other American cities caught up in 20th century progress, continues to be itself, a city of live and let-live, of tolerance and toleration, of likes and dislikes. No better characterization of New Orleans can be found than that of Grace King, a great Southern lady of letters:

"New Orleans is, among cities, the most feminine... arbitrary in her dislikes, tyrannical in her loves, high tempered, luxurious, pleasure-loving... an enigma to prudes and a paradox to Puritans..."

NEW ORLEANS

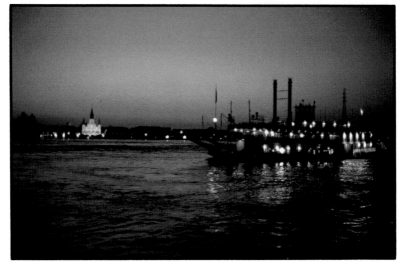

The photographer and publisher
would like to thank the following people
for the encouragement and help they gave
us in producing this book:
Gilbert Bochet, French consul—general in New Orleans,
Hugh Kohlmeyer,
Thomas Lemann.
Our very special thanks to Jack Kiefner of
the Greater New Orleans Tourist Commission.
Printed in June 1984
Publisher's number: 238

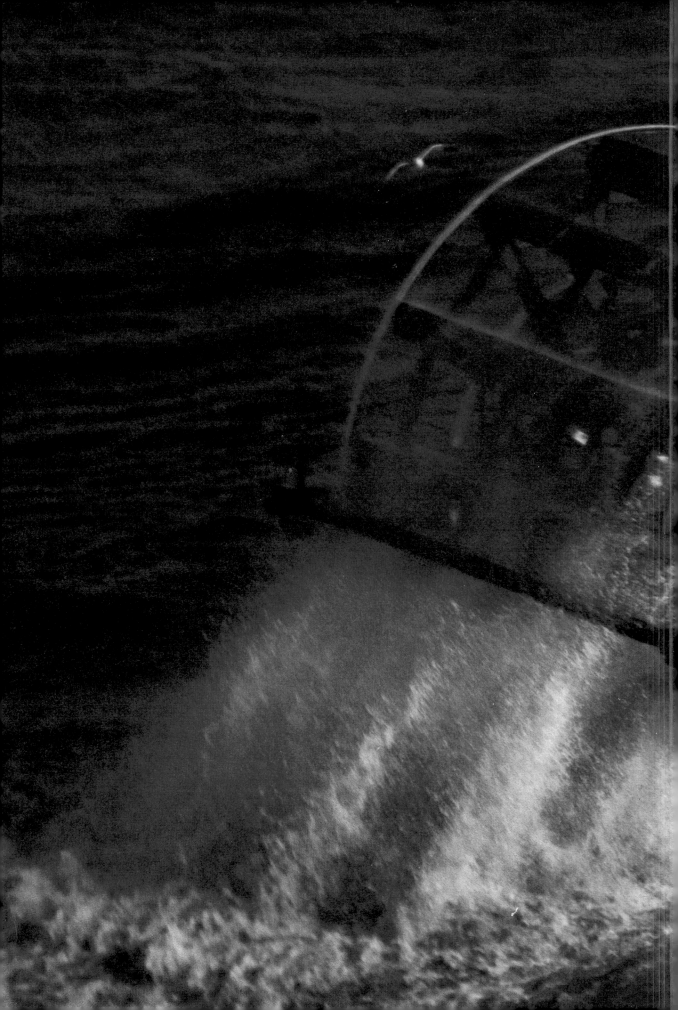